T0154704

Lluís Domènech i Montaner
Palau de la Música Catalana, Barcelona

Text
Manfred Sack

Photographien/Photographs
Hisao Suzuki

Edition Axel Menges

Herausgeber/Editor: Axel Menges

Veröffentlicht in Zusammenarbeit mit der Fundació
Orfeó Català – Palau de la Música Catalana.
Published in co-operation with the Fundació Orfeó
Català – Palau de la Música Catalana.

© 1995 Edition Axel Menges, Stuttgart
ISBN 3-930698-08-0

Alle Rechte vorbehalten, besonders die der Über-
setzung in andere Sprachen.
All rights reserved, especially those of translation
into other languages.

Englische Übersetzung/English translation:
Christina Rathgeber
Gestaltung/Design: Axel Menges

Printed in Korea.

Inhalt

Contents

Im Rausch der Sinne: der Palau de la Música Catalana von Lluís Domènech i Montaner

Wie denn auch anders: Es ist Antoni Gaudí, dem die meisten ihre erste Begegnung mit Barcelona verdanken. Gaudí, nicht wahr, das ist Barcelona! Doch Barcelona ist, zum Glück, nicht bloß Gaudí, sondern vieles mehr. Es ist auch die Stadt von Josep Puig i Cadafalch und, ganz besonders, die von Lluís Domènech i Montaner. Es ist die Kapitale des katalanischen »Modernisme«, dieses eigenwilligen, national bewegten Selbstbefreiungsstiles, der, wenn überhaupt, viel weniger bekannt ist als seine mittel- und nordeuropäischen Varianten, als der deutsche (österreichische, belgische, tschechische) Jugendstil, als der französische Art Nouveau, die britische Arts- and-Crafts-Bewegung, die italienische Architettura Liberty. Man sollte auch gleich den Versuch unterlassen, das Wort Modernisme zu übersetzen. Im Englischen meint »modernism« das, was im Deutschen die (unterdessen klassisch genannte) »Moderne« ist, mithin jene Bewegung, welcher der Jugendstil – und somit auch der katalanische »Modernisme« – den Weg eröffnet hat. »Modernismus« wiederum bezeichnet im Deutschen keinen Stil, sondern seine vulgäre, sich an der Oberfläche austobende, insofern der Mode unterworfene Manipulation. Der Modernisme hingegen war, um die Verwirrung fortzusetzen, die eigensinnige katalanische Moderne der Jahrhundertwende, war die politisch motivierte, mit Hilfe der Tradition (und der Gotik) bewältigte Befreiung, sagen wir: war eine befreiende Umdeutung von Historismus und Eklektizismus und somit der Vergangenheit gegenüber ungleich versöhnlicher als der Jugendstil.

Gaudí wurde zum Synonym dieser imponierenden, dieser ausschweifenden ästhetischen Selbstfindungsbewegung. Sein Name strahlte so intensiv, daß sein Schatten die Namen aller anderen Architekten begrub, obwohl ihre baukünstlerische Leidenschaft um keinen Deut moderater und außerdem oft entschiedener als die seine mit politischer Aktivität gepaart war: für ein neues, ein erneuertes, selbstbewußtes Katalonien.

Und so geschah es, daß Domènech i Montaner, der Schöpfer des Katalanischen Musikpalastes in Barcelona, in dem nicht wenige sogar das katalanischste aller katalanischen Bauwerke erkennen zu können glauben, außerhalb des Landes nahezu unbekannt blieb. Obwohl Domènech auch das bedeutendste Krankenhaus der Stadt entworfen hat, das Hospital de la Santa Creu i de Sant Pau unweit der Kathedrale Sagrada Familia von Gaudí, das Verlagshaus Montaner i Simón an der Carrer d'Aragó, in dem jetzt die Tàpies-Stiftung untergebracht ist, das Café-Restaurant am Parc de la Ciutadella, das jetzt Zoologisches Museum ist. Nicht zu reden von den stattlichen Wohnhäusern, die nach seinen Entwürfen errichtet worden sind.

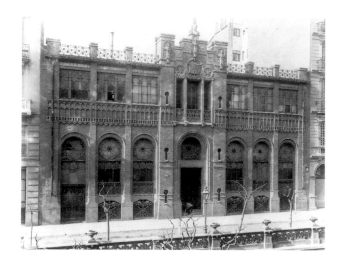

Jedem, der den Palau de la Música Catalana entdeckt, verschlägt es zuerst einmal den Atem. Jeder fühlt sich, selbst wenn der kritische Verstand sich allmählich wieder aus der sinnlichen Überwältigung löst, verzaubert. Jeder bemerkt, wie die Sprache in Wortverbindungen mit Wunder, Märchen, Staunen und Zauber Zuflucht sucht. Wahrscheinlich ist keine Begegnung mit diesem, sich der Üppigkeit so unverhohlen, so virtuos, zugleich so diszipliniert ergebenden Baukunstwerk so intensiv wie diejenige, welche sich aus Unkenntnis ergibt, sich also durch den Zufall des Augenblickes anbahnt: Ich erzähle von mir.

Ausdrücklich auf Gaudí fixiert, dessen Spur zu folgen mich schon einige Tage beschäftigt hatte, kam ich eines Tages von der Plaça de Catalunya in die Carrer Fontanella, bog nach Süden in die zum Hafen hinunterführende Via Laietana, eine quer durch die Altstadt geschlagene, sehr stattliche, vom Atem der Gründerzeit durchwehte Geschäftsstraße ein, wo sich mir, als ich umherblickte, linkerhand plötzlich eine rätselhafte Erscheinung bot: Eingepfercht in ein Gewirr enger Gassen, wirft sich ein rotes Gebäude in die Brust. Auf den ersten Blick sah ich ihm an, daß es sich mit seiner überreich ausgestatteten, stark gegliederten Fassade gegen die Enge und die Gewöhnlichkeit der Umgebung zu behaupten versucht. Ich sah: roten Ziegel-

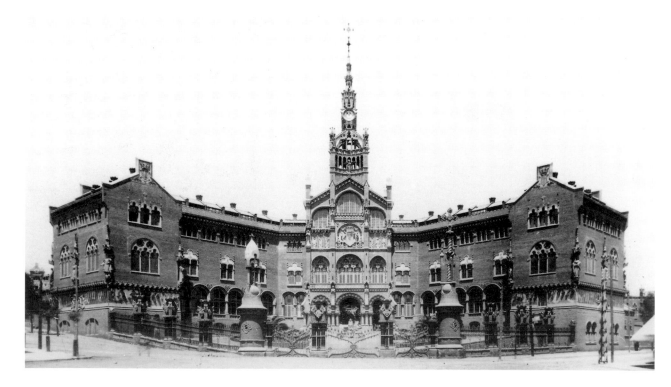

An intoxication for the senses: the Palau de la Música Catalana built by Lluís Domènech i Montaner

How could it be any different: most people owe their first contact with Barcelona to Antoni Gaudí. After all, Gaudí is Barcelona! But fortunately, Barcelona is not just Gaudí. It is much more. It is also the city of Josep Puig i Cadafalch and especially of Lluís Domènech i Montaner. It is the capital of Catalan »Modernisme«, an independent and nationalistically coloured style of self-liberation. Modernisme is far less familiar – when it is known at all – than its central and northern European variations: German (Austrian, Belgian, Czech) Jugendstil, French Art Nouveau, the British Arts and Crafts movement, and Italian Architettura Liberty. One should not even make the attempt to translate the term Modernisme. In English, Modernism refers to that which is known in German as the *Moderne* (and is often preceded by the term »classic«). Jugendstil and by extension Catalan Modernisme prepared the way for Modernism. On the other hand, the German term *Modernismus* does not describe a style but rather its vulgar, superficial manipulation which is subject to the dic-

tates of fashion. To confuse the matter still further, Modernisme was the self-willed Catalan Modernism of the late nineteenth and early twentieth centuries. It was a liberation which was politically motivated and aided by tradition (and the Gothic style); one could call it a liberating reinterpretation of historicism and eclecticism. It was thereby also incomparably more compromising towards the past than was Jugendstil.

Gaudí became a synonym for this impressive and excessive aesthetic self-liberation movement. His name shone so intensively that the names of all other architects were hidden in its shadow, even though their architectural passion was no less intense than his, and, moreover, was often much more conclusively paired with political activities for a new, renewed, self-confident Catalonia.

And that is why Domènech i Montaner, the creator of the Catalan Music Palace in Barcelona, a building which many even consider to be the most Catalan of all Catalan buildings, has remained virtually unknown outside of Catalonia. This, despite the fact that this architect also designed the city's most important hospital, the Hospital de la Santa Creu i de Sant Pau close to Gaudí's Sagrada Familia Cathedral, as well as the

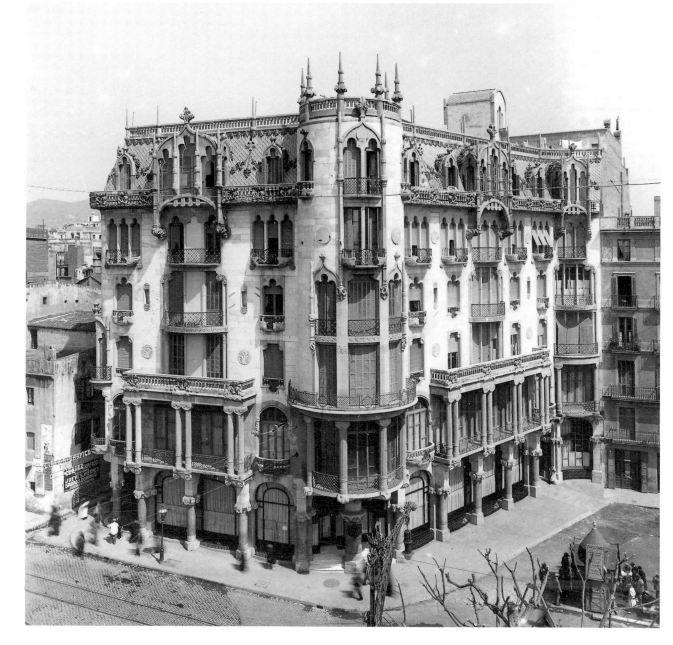

1. Lluís Domènech i Montaner. Hospital de la Santa Creu i de Sant Pau, Barcelona, 1902–10. (Instituto Amatller de Arte Hispánico)
2. Lluís Domènech i Montaner, Editorial Montaner i Simón, Barcelona, 1880. (Instituto Amatller de Arte Hispánico)
3. Lluís Domènech i Montaner, Casa Fuster, Barcelona, 1908–10. (Instituto Amatller de Arte Hispánico)

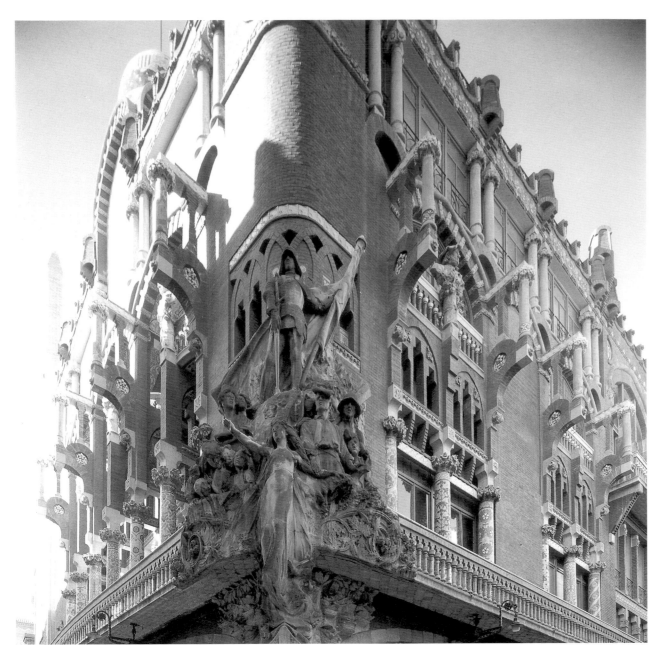

stein, leuchtende Majoliken in betörenden Dekors, viele schlanke und ein paar sehr dicke Säulen, die die Straßenecke der Carrer Sant Pere més Alt, durch die ich gekommen war, mit der Carrer d'Amadeu Vives markieren und das Haus zugleich öffnen. In der zweiten dicken Säule saß, hinter einem Rundbogenfenster, eine Dame, die Kartenverkäuferin des Konzerthauses, das hier seinen versteckten, aber von jeher von jedermann gefundenen Haupteingang hatte. Ich machte noch am selben Abend Bekanntschaft mit dem Konzertsaal selbst.

Es war eine verwirrende, erregende, die Sinne aufwühlende Begegnung, die alle ästhetischen Ekstasen Gaudís vergessen machte. Dieser strahlende Raum! Diese überwältigende Heiterkeit! Alles darin fließend, das Licht, die Farben, die Ornamente. Alles leuchtend, ja funkelnd – Backstein, Majolika, Glas, Metall. Dennoch wirkt nichts aufgeregt, sondern merkwürdig selbstverständlich, miteinander verknüpft, aufeinander bezogen. Der ganze Saal – eine mächtige, musikumarmende Gebärde. Sie wirkt wohl deswegen so gelassen, weil sie von einer ganz außerordentlichen handwerklichen Solidität geprägt ist. Viele Konzertsäle geben ihrem Publikum ein ästhetisch sublimier-

tes, angenehm zu empfindendes Geborgenheitsgefühl; dieser aber stimmt das seine vergnügt, versetzt es dabei unmerklich in eine festliche, nicht feierliche Stimmung, öffnet den Geist für die Botschaften der Musik.

Es konnte hier übrigens früher, als der Saal noch nicht klimatisiert war, passieren, daß sich – so wie im Großen (dem »Goldenen«) Musikvereinssaal in Wien –, wenn der Sommerhitze wegen die Fenster unter der Decke geöffnet waren, Donner und prasselnder Gewitterregen unter die Musik mischten und die Zuhörer darauf aufmerksam machten, daß sie nicht auf einem akustisch nach außen verbarrikadierten Eiland sitzen, sondern in einem von Fenstern umgebenen Raum, in den das Licht der Sonne hereinfällt und der durch seine bunten Scheiben nach außen bekanntgibt, daß sich in seinem Innern Leben regt. Einige Augenblicke lang gibt man der Vermutung nach, nirgendwo anders als hier sei das Wort Atmosphäre gefunden worden.

Das Staunen, übrigens, verliert sich nicht. Je genauer man seine Ursache kennenlernt, desto aufgeschlossener gibt man sich ihm hin.

4. Lluís Domènech i Montaner, Palau de la Música
Catalana, Barcelona, 1905–08. Ostecke des Gebäu-
des. (Photo: Hisao Suzuki)
5. Lluís Domènech i Montaner, Palau de a Música
Catalana, Barcelona, 1905–08. Lageplan.

4. Lluís Domènech i Montaner, Palau de la Música
Catalana, Barcelona, 1905–08. East corner of the
building. (Photo: Hisao Suzuki)
5. Lluís Domènech i Montaner, Palau de la Música
Catalana, Barcelona, 1905–08. Site plan.

building for the publishing house Montaner i Simón on the Carrer d'Aragó, in which the Tàpies Foundation is now located, and the Café-Restaurant at the Parc de la Ciutadella, now the Zoological Museum. To say nothing of the magnificent residential buildings which were built according to his designs.

Seeing the Palau de la Música Catalana for the first time takes everybody's breath away. Even when the critical intellect gradually begins to extricate itself from the sensual deluge, everybody is left enchanted. Everybody notices how language seeks a refuge in word associations with miracles, fairy-tales, astonishment and magic. Probably no encounter with this built work of art, which has yielded so openly to opulence and yet has done so with such virtuosity and discipline, is as intensive as the unexpected encounter, the one which occurs purely by chance. I am talking about myself.

Exclusively concentrated on Gaudí, whose trail I had already been following for a few days, I one day entered the Carrer Fontanella from the Plaça de Catalunya, turned south into the Via Laietana – a very imposing shopping street with a Belle Epoque atmosphere, it runs straight through the old town and leads to the harbour – when, looking around, I suddenly saw a strange sight to my left. Hemmed in by a maze of narrow alleys, was a conspicuous red building. At first sight I could already see that with its lavishly ornamented and strongly articulated façade, it was attempting to assert itself against its narrow confines and the commonness of its surroundings. I saw red brick, shining majolicas in bewitching patterns; many slender and a few extremely fat columns, which marked the corner of the Carrer Sant Pere més Alt, through which I had come, and the Carrer d'Amadeu Vives, and at the same time also opened up the building. In the second fat column a woman sat behind a rounded window and sold the tickets for this concert house. Although the main entrance was hidden away here, everybody had always been able to find it. On that very evening I became acquainted with the concert hall itself.

It was a confusing, stimulating meeting, which stirred up the senses and made me forget all of Gaudí's aesthetic excesses. This radiant room! This overwhelming cheerfulness! Everything in it flowed, the light, the colours, the ornaments. Everything shining, yes, even sparkling – brick, majolica, glass, metal. And yet nothing seems agitated but rather oddly natural, connected and interrelated. The entire hall – an expansive gesture which embraces music. It only appears to be so calm because of the exceptionally high standard of its craftsmanship. Many concert halls provide their audiences with an aesthetically sublimated and pleasant sensation of security but this hall makes its audience feel cheerful. Imperceptibly, it puts it into a festive but not solemn mood and opens the spirit for music's messages.

When the room was not yet air-conditioned, it could happen here – as in the large »Golden« Musikverein concert hall in Vienna –, that the windows below the ceiling were opened because of the summer heat and the sounds of thunder and drumming rain mingled with the music and reminded the audience that it was not sitting on an island which has been barricaded acoustically against the outside world, but rather in a room surrounded by windows which let in the light of the sun, and whose coloured panes let the world outside know that there is life going on inside of it. For a few moments one is tempted to believe that the word atmosphere could only have been invented here.

This astonishment, by the way, does not disappear. The more one understands its cause, the more openly one succumbs to it.

Three minutes of history

It might be necessary to remember that there were centuries of discord between the Catalonians and the Aragons and Castilians. It began in 1469, when the marriage of Ferdinand of Aragon to Isabella of Castile brought Catalonia into the possession of the

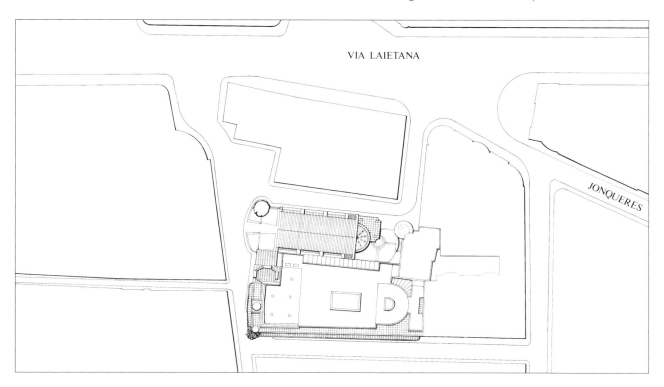

Drei Minuten Geschichte

Man erinnere sich daran, daß es zwischen den Katalanen und den Kastiliern und Aragoniern einen mehrere Jahrhunderte währenden Zwist gegeben hat. Er hatte im Jahr 1469 begonnen, als Ferdinand von Aragonien Isabella von Kastilien heiratete und Katalonien somit ein Teil der spanischen Monarchie wurde. 1714, am Ende des spanischen Erbfolgekrieges, der ganz Europa auf die Schlachtfelder getrieben hatte, nur weil die ältere Schwester Karls II., des letzten spanischen Habsburgers, auf ihr spanisches Erbe verzichtet und damit ungeahnte Begehrlichkeiten geweckt hatte – 1714 also hatte das unterlegene Katalonien seine eifersüchtig verteidigten Sonderrechte verloren. Der habsburgische Erzherzog Karl mußte sich schließlich dem spanischen König Philipp V. unterwerfen. Seitdem gab es das, was man verharmlosend »die katalanische Frage« nennt. Seitdem strebten die Katalanen nach der nationalen Unabhängigkeit oder doch zumindest nach der Verwaltungsautonomie innerhalb Spaniens.

Im Jahr 1932 endlich wurde Katalonien der Autonomiestatus gewährt; seine vier Provinzen werden seitdem von der Generalitat de Catalunya regiert. Die Ausrufung der absoluten Unabhängigkeit scheiterte jedoch an General Franco, der mit den Separatisten im Nordosten der Pyrenäenhalbinsel hart umging, der sogar die katalanische Sprache unterdrückte. Erst im Jahr 1975 hörte es damit auf. Dies tat sich, nicht untypisch, in der Nachricht kund, daß die katholische Kirche das Katalanische (und das Baskische) *de jure* anerkenne. Noch heute spürt man in Katalonien einen besonders ausgeprägten Patriotismus, der nicht zuletzt im betont konsequenten Gebrauch der eigenen Sprache im Alltag wie in der Literatur zum Ausdruck kommt.

Gegen Ende des vorigen Jahrhunderts war »die katalanische Frage« so akut geworden, daß das Streben nach kultureller Autonomie auf einmal alle Künste mit sich riß. Wenn sie schon politisch unerreichbar war, sollte sie doch die Umwelt und das Dasein erkennbar prägen. Alles schien dafür günstig. In ganz Europa herrschte Gründerzeit, im alten gesellschaftlichen Gefüge machte sich intellektuelle Unruhe bemerkbar. Die Industrialisierung weckte Zweifel an den stilistischen Ausschweifungen des Eklektizismus und des Historismus, an der Willkür seiner aufgeblasenen, verstaubten Gehrock-Ornamentik. Man war sich überraschend schnell klar darüber, daß das soeben in Gang gekommene Zeitalter der Maschine und der Industrie eine andere Ästhetik, eine Alltagskultur neuer Art, eine von Überkommenem befreite, selbstbewußte, evolutionäre, kurzum eine neue Kunst notwendig mache.

Alles das mündete zusammen mit der enormen nationalen Aufbruchsstimmung in Katalonien in eine Bewegung, die unter der Bezeichnung Modernisme zusammengefaßt wird und die die gemachte Welt in einer Art von Gesamtkunstwerk zu bündeln versuchte. Die intellektuelle, nicht zuletzt vom aristokratischen wie vom industriellen Bürgertum bewegte, sehr komplexe Strömung begann, wie der mitteleuropäische Jugendstil, gegen 1890 und endete im Ersten Weltkrieg.

Treibende Kraft war nicht nur die in Katalonien aufblühende Industrie, sondern auch das bürgerliche Selbstbewußtsein, war die Sehnsucht nach geistiger und politischer Autonomie. Daraus bildete sich schließlich die erstaunlich ausgeprägte, alle Künste einschließende Physiognomie dieser kurzen, lebhaften, ungemein fruchtbaren Epoche. Die katalanische Besonderheit dieser Anstrengung war ihre nationale Autochthonie. Deswegen ist der Modernisme auch mehr als nur eine Spielart des Jugendstils.

Der Chor Orfeó Català

Das politische Gleichgewicht, das Spanien zu Beginn der neunziger Jahre unseres Jahrhunderts kennzeichnet, dokumentierte das Land mit drei erfolgreich durchgesetzten internationalen Ereignissen: Madrid war 1992 »europäische Kulturhauptstadt«, Barcelona im selben Jahr Ort der Olympischen Spiele, und Sevilla feierte (mit der üblichen architektonischen Modenschau) die Weltausstellung, ein Ereignis, mit welchem sich Barcelona lange vorher hervorgetan hatte. Zu erinnern ist da freilich nicht nur an die vom Jahr 1929 – die unter anderem den ein halbes Jahrhundert später rekonstruierten deutschen Pavillon Ludwig Mies van der Rohes hervorgebracht hatte –, sondern vor allem an die des Jahres 1888, mit der die katalanische Metropole ihre Fortschrittlichkeit beweisen wollte. Es war, selbstverständlich, eine hektische Gewaltanstrengung; doch sie wurde zum Signal des Aufbruchs in ein neues, stolzes, katalanisch geprägtes Zeitalter der frühen Moderne. Wen wundert es, daß sich im selben Jahr nicht allein Barcelona vom Eifer hatte packen lassen, die Welt auf sich aufmerksam zu machen, sondern auch Brüssel, Melbourne und Moskau? Welch eine Konkurrenz, und welch ein Konkurrenzgetümmel auf dem Erdenrund! Es läßt etwas vom Temperament der Zeit ahnen – und vom Versuch, sie für sich zu nutzen, industriell, wirtschaftlich, aber auch politisch und künstlerisch. So wurde diese Veranstaltung zum Stimulus des allumfassenden Modernisme.

Im Rahmen der Weltausstellung traten in Barcelona auch mehrere internationale Chöre auf, was zwei junge idealistische Musiker, Lluís Millet und Amadeu Vives, dazu anregte, einen Chor von gänzlich eigenem Charakter und kulturpolitischen Anspruch zu gründen, eingebettet in einen Musikverein gleichen Namens. So entstand am 15. September 1891 der Orfeó Català, der – programmatisch so genannte – Katalanische Orpheus. Und der hatte sich von Anfang an gleichermaßen zwei Aufgaben zugewandt: der Interpretation des klassischen europäischen Repertoires und der Pflege des autochthonen Volksliedes. Immer ging es der Chorvereinigung um beides.

Der Orfeó Català entfaltete eine erstaunliche Aktivität. Er brachte zum ersten Mal in Barcelona Werke Richard Wagners zur Aufführung, ebenso die Neunte Symphonie und die Missa Solemnis von Beethoven, Bachs Magnificat, auch dessen Passionen und Kantaten, Monteverdis »Orfeó«, Berlioz' Requiem sowie Stücke von Palestrina, Haydn und Mozart, kurzum: der Orfeó Català nahm sich die ganze große europäische Chormusik vor, entdeckte das Madrigal neu, pflegte die religiöse Polyphonie und richtete die musikalische Neugier zugleich auf die große europäische Symphonik. 1895 regte ein Auftritt des russischen Nationalchors in Barcelona dazu an, den Chor zu ergänzen. Schon im Jahr darauf entstanden zusätzlich ein

Spanish crown. On the losing side in the War of the Spanish Succession – all of Europe had taken to the battlefield simply because the older sister of Charles II, the last Spanish Habsburg, had relinquished her rights to the throne and thereby opened up enticing new possibilities – in 1714, Catalonia lost its jealously guarded privileges. The Habsburg arch-duke Charles had to submit to the Spanish king, Philip V. Since this point there has been what is known in its most harmless form as »the Catalan question«. Since this point Catalans have been striving for separation or at least administrative autonomy within Spain.

In 1932 Catalonia was finally granted autonomous status, and ever since its four provinces have been ruled by the Generalitat de Catalunya. A declaration of complete independence was thwarted, however, by General Franco, who dealt harshly with the separatists in the northeastern Iberian peninsula, even suppressing the Catalan language. This only came to an end in 1975. It was not untypical that this was made known through the announcement of the de jure recognition of the Catalan (and Basque) languages by the Catholic Church. Still today there is a distinct patriotic feeling in Catalonia; one of the ways in which this is expressed is the rigorous use of the native language in both daily life and literature.

Towards the end of the last century, the »Catalan question« had become so acute that aspirations for cultural autonomy suddenly swept through all of the arts. If this autonomy could not be achieved in political terms, then it should at least visibly shape the environment and day-to-day existence. It seemed to be a very opportune moment for such an endeavor. This was a time of rapid industrial expansion everywhere in Europe and an intellectual fermentation was becoming apparent in the old social structure. The industrialization process raised doubts about the stylistic excesses of eclecticism and historicism and the capriciousness of its pompous ornamentation. One was surprisingly quick to realize that the recently inaugurated era of the machine and of industry demanded a different aesthetics, a new type of culture for daily life; an art which was free of traditions, self-confident, and evolutionary – in short: a new art. This all converged with a tremendous sense of nationalist awakening in Catalonia and became concentrated in the movement known as Modernisme, which attempted to unite different elements of the man-made world into a sort of Gesamtkunstwerk. This intellectual and highly complex movement, which was propelled by the aristocratic and industrial bourgeoisie, emerged around 1890 – like Central European Jugendstil – and came to an end during the First World War.

The driving force was not just Catalonia's burgeoning industrial strength, but also the self-confidence of its bourgeoisie and its desire for intellectual and political autonomy. This brief, lively and immensely fertile epoch would eventually acquire an astonishingly distinctive physiognomy which encompassed all of the arts. The peculiarly Catalonian feature in this effort was its nationalist autochthonous nature. For this reason Modernisme is also more than merely a Jugendstil variation.

The Orfeó Català choir

Spain recently documented its current political equilibrium with three successfully staged international events. In 1992 Madrid was Europe's »cultural capital«, and in the same year the Olympic Games took place in Barcelona, and Seville hosted the World Exhibition (with the usual architectonic fashion show). Barcelona had already distinguished itself with a World Exhibition much earlier. One is thinking here not so much of the year 1929, when its World Exhibition was among other things the site of Ludwig Mies van der Rohe's German pavilion – which would be reconstructed fifty years later – but of its World Exhibition in 1888, when the Catalan capital wanted to demonstrate the progress which it had made. It was of course a hectic show of strength but it also set the signal for the emergence of a new, proud and distinctively Catalan Modern age. In this year, other cities – Brussels, Melbourne and Moscow – were also vying for international attention. What competition! Indeed, there seems to have been a tumult of competition in the world at this time. It gives one a sense of the mood of this era and of the attempt to derive benefits from it, that were not only industrial and economic but also political and artistic. This event would become the stimulus for the sweeping Modernisme movement.

During this World Exhibition a number of international choirs performed in Barcelona, and this motivated the two young, idealistic musicians, Lluís Millet and Amadeu Vives, to found a choir – linked to a musical association of the same name – with its own distinct character and cultural and political objectives. The Orfeó Català was created on 15 September 1891 – the programmatically named »Catalan Orpheus«. From the very beginning, this choir set itself two tasks: the interpretation of the classical European repertoire and the cultivation of the autochthonous folk-song. This choral society was always concerned with both.

The Orfeó Català developed an astonishing range. It was responsible for the first performance of Richard Wagner's works in Barcelona, as well as Beethoven's Ninth Symphony and Missa Solemnis, Bach's Magnificat, Passions and Cantatas, Monteverdi's Orfeó, Berlioz's Requiem, and pieces by Palestrina, Haydn and Mozart. In short, the Orfeó Català took on the entire huge corpus of European choral music, rediscovered the madrigal, cultivated the religious polyphony and also directed attention towards Europe's great symphonic music. In 1895, a performance by National Russian Chapel in Barcelona led to the idea of expanding the choir, and only a year later further choirs for women and children were created. The Orfeó Català was soon counted amongst Europe's most important choirs and was invited to guest performances. One of the things that the critics always noted about it was its membership of workers and craftsmen. This had always been an important consideration for José Anselmo Clavé (1824–1874), who had founded Spain's first male choral society (»La Fraternidad«) in Barcelona in the middle of the century and fostered the cultivation of choral music in the city.

Along with Lluís Millet and Amadeu Vives, Clavé and the ethnochoreologist and collector of folk-songs, Aurelio Capmany i Farré (1868–1954), must also be counted as the spiritual fathers of the Orfeó Català. In the beginning, this choir led a nomadic existence, re-

Frauen- und ein Kinderchor. Bald zählte man den Orfeó Català zu den wichtigen Chören Europas und lud ihn zu Gastkonzerten ein. Die Kritik nahm aber auch davon Kenntnis, daß seine Mitglieder nicht zuletzt Arbeiter und Handwerker waren. Darauf hatte José Anselmo Clavé (1824–1874), der Mitte des Jahrhunderts den ersten spanischen Männergesangverein (»La Fraternidad«) gegründet und die Chorkultur in der Stadt zu pflegen begonnen hatte, immer geachtet.

Der Orfeó Català, zu dessen geistigen Vätern neben Lluís Millet und Amadeu Vives ja auch Clavé und der Volkstanzkundler und Volksliedsammler Aurelio Capmany i Farré (1868–1954) gehörten, führte anfangs ein nomadisches Dasein, probte hier, probte dort, konzertierte in verschiedenen, seinem Anspruch nicht immer genügenden Sälen. Der Wunsch nach einer Heimat, einem eigenen Konzertsaal wuchs. Es galt als ausgemacht, daß das erträumte Bauwerk außerordentlich zu werden hätte, ein katalanisches Gesamtkunstwerk. Im Oktober 1904 wurde das Grundstück erworben und der Architekt Lluís Domènech i Montaner mit dem Entwurf des Gebäudes beauftragt, im April 1905 legte man den Grundstein. Im Februar 1908, siebzehn Jahre nach seiner Gründung, zog der Orfeó Català in sein Haus ein. Es war, wie gewünscht, ein signifikantes, ein unverwechselbares, einprägsames, inspirierendes, ein durch und durch als katalanisch empfundenes, ausdrücklich modernes Bauwerk. Tatsächlich war der Palau de la Música Catalana niemals nur ein Konzertsaal, sondern, mitten in der Altstadt Barcelonas gelegen, Inbegriff des Landes und seiner Kultur. Zur Eröffnung spielte das Philharmonische Orchester Berlin unter Leitung des Komponisten Richard Strauss, der Orfeó sang, es konzertierte der katalanische Cellist Pablo Casals, Albert Schweitzer schlug die Orgel. Lluís Millet hielt die Ansprache. Jeder Schmuck, sagte er, verlange nach einer Schatulle,
jede Idee brauche eine Form, jede Kunst den ihr angemessenen Ort, an welchem ihre Schönheit den Geschmack des Volkes zu bilden vermöchte. Es ist anzunehmen, daß er seinen Architekten umarmt hat. Denn die 1878 von dem damals 28jährigen Lluís Domènech i Montaner in der Zeitschrift La Renaixença ausgerufene »Suche nach einer nationalen Architektur« hatte dieser nun selber mit diesem Baukunstwerke gekrönt.

Mit damals knapp zweihundert Sängern und fast vierzehnhundert fördernden Mitgliedern stellte der Orfeó geradezu eine musikalische Volksbewegung dar, deren Elan sich auch die Stadt nicht zu entziehen vermochte. Sie stand denn auch für die Finanzierung des Gebäudes gerade. Dennoch gehört der Musikpalast den Mitgliedern des Orfeó Català.

»Freunde«, jubelte Joaquim Cabot, der Präsident der Chorvereinigung am Tage der Eröffnung, »wir haben ein Zuhause! Freut euch über die Verwirklichung unseres Traumes!« Der Komponist Lluís Millet sprach von einem Gefühl, das sie alle in diesem Saal mit seiner »hochzeitlichen Gewandung« »wie einen Gesang in sich« empfunden hätten.

Millet, der 1941 in Barcelona starb, war ein regsamer und offensichtlich phantasievoller Mann. Ein Jahr, bevor der Bau beschlossen wurde, hatte er eine Zeitschrift mit dem Titel Revista Musical Catalana gegründet, ein bis 1936 erschienenes Blatt von großer Reputation. Auf ihn geht auch die reichhaltige, weit über zwanzigtausend Bände zählende Musikbibliothek des Chores zurück, nicht gerechnet die kostbaren Archivalien, darunter zahlreiche Musikerhandschriften und Autographen.

Der Architekt

Lluís Domènech i Montaner war neben Antoni Gaudí der kreativste und eindrucksvollste Architekt des Modernisme in Barcelona. Und wie Gaudí und der jüngere Josep Puig de Cadafalch war er ein glühender Patriot, dem ein autonomes Katalonien vorschwebte und der als Politiker tatkräftig dafür focht. Vielleicht hatte gerade dies unsere viel zitierten Baugeschichtsschreiber – wie damals übrigens auch manche Zeitgenossen – so irritiert, daß sie ihn nicht zur Kenntnis nahmen. Vielleicht kannten sie ihn auch bloß nicht. Weder Sigfried Giedion noch Leonardo Benevolo oder Nikolaus Pevsner erwähnen ihn in ihren Büchern, es gibt immer noch keine Biographie auf deutsch. Sogar die meisten Jugendstil-Experten tun sich mit dem katalanischen Modernisme schwer. Die einzige gründliche und gescheite Darstellung schrieb der Engländer Tim Benton in dem 1979 von Frank Russell herausgegebenen Band Art Nouveau Architecture. Eine andere ist dem englischen, in Barcelona ansässigen Architekten David Mackay zu danken (Modern Architecture in Barcelona 1854–1939). Erstaunlicher noch ist, daß das erste Buch über das Thema (Alexandre Cirici Pellicers El Arte modernista en Barcelona) erst Mitte unseres Jahrhunderts erschien. Maria Lluïsa Borràs, die die erste Biographie über Domènech i Montaner verfaßte (Domènech i Montaner, Barcelona 1970), versucht den Mangel unter anderem damit zu erklären, daß die Bürger Barcelonas ihm niemals von Herzen Beifall gespendet hätten, obwohl er die Stadt mit mehr als zwanzig, durchweg charaktervollen Bauten bereichert hat.

Maria Lluïsa Borràs nennt noch einen anderen Grund für diese Reserviertheit: Es seien die Noucentisten der nächsten Generation, die die neugotisch beflügelten Modernisten verabscheuten und einen mediterranen Neoklassizismus propagierten. Und dann waren manche auch der Ansicht, daß der Hochschullehrer Domènech, der Architekturschuldirektor, der Wissenschaftler und Politiker dem Architekten nicht gutgetan, sagen wir, den Rang streitig gemacht habe, ein Urteil allerdings von Leuten, die mit Blindheit geschlagen sein müssen.

Lluís Domènech i Montaner wurde 1850 in Barcelona geboren. Er studierte in Madrid Architektur und wurde 1875, schon zwei Jahre nach dem dort erworbenen Diplom, als Professor an die Architekturschule Barcelonas berufen, der er dann von 1900 bis 1923 als Direktor vorstand. Am Anfang seiner Karriere war er, zusammen mit dem um zwei Jahre jüngeren (1878 diplomierten) Antoni Gaudí, Mitarbeiter des damaligen Grandseigneurs der katalanischen Architektur, des Kirchenbauers Juan Martorell i Montells (1833–1906). Dieser war es auch, der die beiden hochbegabten Architekten für das Mittelalter, seine ausgeklügelten Handwerkstechniken, seine Materialvorlieben, namentlich für das konstruktive Abenteuer der Gotik begeisterte. Gemeint war ein damals im platten Historismus verlorengegangener »Stil des Geistes«, der nun mit dem konstruktiven Rationalismus der neuen Zeit, die das Eisen, den Stahl entdeckt hatte, verknüpft wurde.

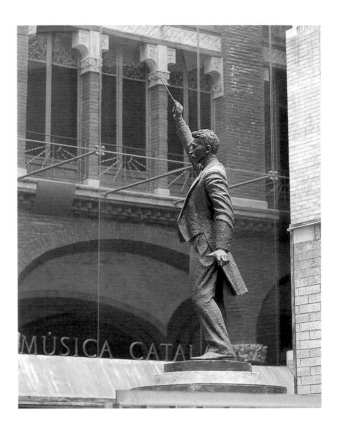

6. Vor dem neuen Eingang: Statue des Komponisten Lluís Millet, Gründer des Orféo Català, dirigierend. (Photo: Hisao Suzuki)

6. In front of the new entrance: staue of the composer Lluís Millet, founder of the Orféo Català, conducting. (Photo: Hisao Suzuki)

hearsing here and there, and performing in different halls which did not always do justice to its standards. The desire for a home, for a concert hall of one's own, became ever more pronounced. It was clear that the envisaged building had to be something extraordinary, a Catalan Gesamtkunstwerk. In October 1904 a site was acquired and the architect Lluís Domènech i Montaner was commissioned with the design for the building. In April 1905 the foundation stone was laid, and in February 1908, seventeen years after its creation, the Orfeó Català moved into its home. The desire for something extraordinary had been fulfilled. It was a significant, unmistakable, highly distinctive, inspiring, utterly Catalan and expressly modern building. In fact, the Palau de la Música Catalana was never just a concert hall. Located in the centre of Barcelona's old town, it epitomized Catalonia and its culture. At its inauguration the Berlin Philharmonic Orchestra was conducted by the composer Richard Strauss, the Orfeó sang, the Catalan cellist Pablo Casals performed, and Albert Schweitzer played the organ. Lluís Millet delivered a speech in which he said, that every jewel needs its casket, every idea requires a form, and every art form must have an appropriate site whose beauty will shape the people's aesthetic sense. One can assume that he embraced his architect. In 1878 the 28-year-old Lluís Domènech i Montaner had announced the »quest for a national architecture« in the journal, La Renaixença. With this building, he was himself responsible for a crowning achievement in this quest.

At this time the Orfeó had almost two hundred singers and 1400 subscribing members. It was thereby akin to a popular movement in support of music. The city could not distance itself from such an ebullient movement and financed the construction of the concert hall. Nevertheless, the music palace belonged to the members of the Orfeó Català.

Joaquim Cabot, the president of the choral association, rejoiced on the inauguration day: »Friends, we have a home! Be joyful that our dream has been realized!« The composer Lluís Millet spoke of a feeling, that everybody in this room with its »bridal apparel« feels »like a song inside of us«.

Millet, who died in Barcelona in 1941, was a lively personality, who obviously had a great deal of imagination. A year before the building was completed, he founded a journal with the title, Revista Musical Catalana, which would enjoy an excellent reputation until it ceased publication in 1936. He was also responsible for the establishment of the choir's extensive music library. Encompassing well over twenty thousand volumes, it also holds valuable archival material which includes the manuscripts and autographs of many musicians.

The architect

Lluís Domènech i Montaner can be ranked with Antoni Gaudí as the most creative and impressive architect of Modernisme in Barcelona. Like Gaudí and the younger Josep Puig de Cadafalch, he was also a fervent patriot, who envisaged an autonomous Catalonia, and as a politician, he lent his active support to this goal. Perhaps it was precisely this which so irritated well-known architectural historians – as well as some of his con-

temporaries – that they took no notice of him. Or maybe they simply were not aware of him. Neither Sigfried Giedion nor Leonardo Benevolo nor Nikolaus Pevsner mention him in their books, and there is still no biography of him in German. Even most of the Jugendstil experts have difficulties with Catalan Modernisme. The only thorough and intelligent description was written by the Englishman, Tim Benton, in Art Nouveau Architecture (edited by Frank Russell and published in 1979). David Mackay, an English architect living in Barcelona, has also provided a portrayal in his book, Modern Architecture in Barcelona 1854–1939. It is even more surprising that the first monograph on this subject (Alexandre Cirici Pellicer, El Arte modernista en Barcelona) only appeared in the middle of this century. Maria Lluïsa Borràs, who wrote the first biography on Domènech i Montaner (Domènech i Montaner, Barcelona 1970), thinks that one of the reasons for this lacuna lies in the fact that the citizens of Barcelona had never taken him to their hearts, even though he graced their city with more than twenty buildings of great character.

Maria Lluïsa Borràs also gives a further reason for the reserved attitude towards this architect: the Noucentists of the subsequent generation detested the Neo-Gothic, winged Modernists and propagated a Mediterranean Neo-Classicism. And then, there were some who were of the opinion that Domènech's other activities as a university professor, director of the architectural school, scholar and politician did not do him any good as an architect, vied for his attention, so to speak. This judgement, however, could only have been made by people who have been struck blind.

Lluís Domènech i Montaner was born in Barcelona in 1850. He studied architecture in Madrid and in 1875, only two years after obtaining his diploma, he received a professorship in Barcelona's school of architecture. He eventually became the director of this school in 1900 and remained in this position until 1923. At the beginning of his career he worked with Antoni Gaudí (two years younger, he had received his diploma in 1878) for the church architect Juan Martorell i Montells (1833–1906). This grand seigneur of Catalan architecture awakened an enthusiasm in the two highly talented architects for the Middle Ages, for the ingenious techniques of its craftsmen, for its favoured materials, and in particular for the constructive adventure of the Gothic style. At the time, what was meant by this was the »style of the spirit« which had been lost in a shallow historicism. It could now be linked with the constructive rationalism of the new age which had discovered iron and steel.

At the age of nineteen, however, Domènech i Montaner had already been gripped by the possibilities of politics. He was an active participant in Barcelona's first political association, »Young Catalonia«, and in 1887 he was one of the founding members of the »Lliga de Catalunya«. One of his co-founders was Eusebio Güell, who sympathized with the ideas of the English social reformers and would eventually become Gaudí's generous client. He was immediately elected president of the Lliga. More was to come: in 1892 he became president of the Unió Catalunya which he had co-founded, three years later he presided over the Jocs Florals and for three terms of office he headed the Ateneu Barcelonès.

Bereits mit neunzehn Jahren aber hatten Domènech i Montaner die Möglichkeiten einer Betätigung im politischen Bereich gepackt. Er gehörte zu den Aktiven der ersten politischen Vereinigung Barcelonas, des »Jungen Kataloniens«. 1887 gründete er, unter anderem mit Eusebio Güell, der mit den Ideen der englischen Sozialreformer sympathisierte und Gaudís großmütiger Bauherr wurde, die Lliga de Catalunya. Die Lliga wählte ihn alsbald zu ihrem Präsidenten. Nicht genug, wurde er 1892 Präsident der von ihm mitgegründeten Unió Catalunya, drei Jahre darauf stand er den Jocs Florals vor und leitete drei Amtsperioden lang das Ateneu Barcelonès.

Der Architekt Domènech i Montaner war ein durch und durch politischer, vor allem aber ein patriotischer Mensch. Es wäre allerdings einigermaßen unsinnig, zu unterstellen, darunter hätte sein baukünstlerisches Talent gelitten. Er hat seinen Beruf offenbar als eine unter den politischen Sehnsüchten gebildete, die Politik reflektierende ästhetische Mission verstanden. In allen Bauwerken, die er entwarf, spiegelt sich der Traum von der Wiedergeburt Kataloniens. Und wie immer, wenn von einer Renaissance gesprochen wird, stützt sich die Bekennerschaft in der ersten Silbe auf die Tradition und das, worin das neue Katalonien sich wiedererkennen zu können glaubte: ein veredeltes, in die Gegenwart transponiertes, als Inspirationsquelle begriffenes Mittelalter. Und so scheint der katalanische Modernisme dem Expressionismus mit seinen offenen und versteckten Huldigungen an die Gotik näher zu sein als dem Jugendstil anderswo, der der Tradition, der Geschichte und ihrem stilistischen Ballast dadurch zu entrinnen versuchte, daß er die Natur zum Mutterboden der neuen Formen und der neuen Ornamentik erkor (oder, wie die Wiener, die Geometrie). In seinem 1962 erschienenen Buch *Art Nouveau – Jugendstil* nannte Robert Schmutzler den Palau de la Música Catalana ein »Beispiel des historistisch gestörten, ›unreinen‹ Art Nouveau«, und in den 1956 erschienenen *Sources of Art Nouveau* sah Stephan Tschudi Madsen seinen Architekten Domènech »weit entfernt« von dieser mittel- und nordeuropäischen Stilrichtung. Für Maria Lluïsa Borràs dagegen ist der Modernisme ein »Abenteuer des Volkes, das seine eigene Bestätigung in politischen und kulturellen Strukturen« suchte.

In ihrer Biographie über Lluís Domènech i Montaner ist ihr freilich der Architekt sympathischer als der Politiker, denn für die Politik habe er keine besondere Begabung gehabt, er sei kein blendender Redner gewesen, kein spitzfindiger Debattierer, erst recht kein Schaumschläger, der zu Propagandareden fähig gewesen wäre. Er war, zunächst jedenfalls, kein feuriger Linker, sondern ein Konservativer, ein Parteigänger der bürgerlichen Aristokratie und der industriebewußten Kaufmannschaft, der sich ein historisch geprägtes Bild vom neuen Katalonien und seiner neuen Kunst gemacht und auf die religiöse Tradition gebaut hatte, kurzum, der »der Vergangenheit tief verbunden« war. Aber das schloß den klaren Blick auf die Kraft der Industrialisierung, namentlich Kataloniens, das um vieles erfolgreicher als das übrige Spanien war, nicht aus. Und so ging es dem Politiker Domènech auch darum, den katalanischen Lebensstandard auf den des übrigen Europas zu bringen. Deshalb auch sein enormes Engagement für die Weltausstellung 1888, zu der er allein drei Werke beigesteuert hat: Er baute das Rathaus der Stadt um, damit die königliche Familie darin standesgemäß zu logieren vermochte; er schuf das Hotel Paseo de Colon, fünf Stockwerke hoch, 160 Meter lang, mit über tausend Zimmern, das in nur drei Monaten errichtet und nach der Schau wieder abgerissen wurde; schließlich entwarf er das schon erwähnte Café-Restaurant in der Nordostecke des Parc de la Ciutadella. David Mackay ist der Ansicht, Domènech habe mit diesem Eisenskelett- und Backsteinbau Berlages Amsterdamer Börse »vorweggenommen«.

Daß in der Erinnerung an die Gotik nicht nur die himmelwärts strebende Ausdrucksform, sondern viel mehr die Chance einer radikalen konstruktiven Erneuerung der Baukunst verborgen war, hatte Domènech wohl Eugène-Emmanuel Viollet-le-Duc mit seinem *Dictionnaire raisonné de l'architecture française* (1854–1868) nahegebracht, doch nicht nur diesem, sondern ebenso dem logischere, insofern »natürliche« (Pfeiler-)Konstruktionen suchenden Gaudí. Beide gingen dabei verschiedene Wege, aber beide faszinierte offenbar die seltsame Verwandtschaft zwischen der gotischen Pfeiler- und der modernen Eisenskelettkonstruktion. Denn natürlich war der Franzose kein Nachbildner, der sich stumpfsinnig an die Tradition hängte, sondern ein Neuerer, der es auf die Baustoffe und Techniken seiner Zeit abgesehen hatte.

Zugleich aber hatten die Architekten Barcelonas auch gelesen, was der englische Kunsttheoretiker John Ruskin in seinem Buch *Die sieben Leuchter der Baukunst* von 1849 mitzuteilen hatte. In der deutschen Ausgabe von 1900 lautet einer der Abschnitte so: »Wenn wirklich ein Nutzen in unserer Kenntnis der Vergangenheit oder eine Freude in dem Gedanken liegt, ein Andenken zu hinterlassen, das uns Kraft zu gegenwärtigem Streben verleihen kann oder Geduld im Standhalten, so gibt es zwei Pflichten in bezug auf nationale Architektur, deren Wichtigkeit nicht überschätzt werden kann. Die erste besteht darin, die Baukunst der Gegenwart ›historisch‹ (nämlich ›unsere Zeit‹ ausdrückend) zu machen; die zweite, die der Vergangenheit als die kostbarste aller Erbschaften zu erhalten.« Später stößt man dann auf diese Botschaft: »Die Baukunst eines Volkes ist groß nur dann, wenn sie so allgemein und feststehend ist wie seine Sprache, und wenn die provinziellen Stilabweichungen nichts weiter sind als Dialekte.« Ruskins berühmtestes Buch über die Architektur heißt *Von der Natur der Gotik*. Wichtig war wohl auch sein Abscheu gegen die gedankenlose, sentimentale Beschwörung der alten Handwerkskünste, der er sein Plädoyer für eine – ausdrücklich so konzipierte – Industriekunst und einen innovativen Rationalismus in der Architektur entgegensetzte.

Domènech war bereits mit seinem (zusammen mit Josep Vilaseca angefertigten) Wettbewerbsentwurf für die Instituciones Provinciales de Instrucción Pública aufgefallen, weil darin der neugotische Stil schon erstaunlich frei interpretiert worden war. Er hatte sich mit allen damals gebräuchlichen Stilvarianten auseinandergesetzt, mit der Romanik, der katalanischen Neugotik, auch dem mit maurischen Motiven spielenden Neo-Mudéjar. Sein Fazit aber war eindeutig: Es wäre absurd, dergleichen in Stahl und Gußeisen nachzuäffen, es müsse statt dessen ein gänzlich neuer Stil gefunden werden, aber, wie Charles Moore es hundert Jahre später formulierte, »eine Architektur mit einer Erinnerung«. Domènech schrieb in einem Aufsatz der

The architect Domènech i Montaner was political through and through but, above all, he was a patriot. I would be rather ridiculous, however, to profess that his architectural talent suffered as a result. He apparently understood his profession as an aesthetic mission which had developed within the context of political yearnings and which reflected a certain political situation. The dream of a Catalan renaissance is mirrored in all of the buildings which he designed. And as is always the case when one speaks of a renaissance, its proponents emphasized the first syllable – or tradition. The tradition in which the new Catalonia thought that it could recognize itself was that of the Middle Ages. Refined and transported to the late nineteenth century, it was understood as an inspirational source. And that is why Catalan Modernisme – with its open and hidden celebrations of the Gothic style – seems closer to Expressionism than to Jugendstil, for the latter attempted to escape from tradition and history's stylistic ballast by selecting nature as the source for new forms and ornamentation. (In the case of the Viennese this role was assigned to geometry.) In *Art Nouveau – Jugendstil* (1962) Robert Schmutzler referred to the Palau de la Música Catalana as an »example of historically disturbed, ›impure‹ Art Nouveau«, and in *Sources of Art Nouveau* (1956) Stephan Tschudi Madsen described its architect Domènech as being »far removed« from this central and northern European style. In contrast, for Maria Lluïsa Borràs, Modernisme represents an »adventure on the part of the people which sought its own confirmation in political and cultural structures«.

In her biography on Lluís Domènech i Montaner, she is admittedly more sympathetic to the architect than to the politician, for he was not particularly suited to the latter role. He was neither a brilliant orator, nor a particularly subtle debater and certainly not a mudslinger who would have been capable of propagandist speeches. Nor was he – at least not initially – a fiery left-winger but rather a conservative, a supporter of the bourgeois aristocracy and the industrially conscious merchant class: a man who had fashioned for himself a historically influenced image of the new Catalonia and its new art and who trusted in religious tradition. In short, he was a man who »was deeply attached to the past«. But all of this did not rule out a sharp eye for the power of industrialization in Catalonia, which was far more advanced in this respect than the rest of Spain. That is why one of Domènech's concerns as a politician was to bring Catalonia's standard of living on a par with the rest of Europe. This is also the reason for his active and intense participation in the World Exhibition in 1888, to which he contributed three works. He converted Barcelona's town hall so that the royal family would have appropriate lodgings. He created the Paseo de Colon Hotel – five storeys high, 160 meters long, with over a thousand rooms – which was built in only three months and torn down again after the Exhibition. Finally, he designed the above mentioned Café-Restaurant in the northeastern corner of the Parc de la Ciutadella. According to David Mackay, this building's iron skeleton and brickwork »anticipated« Berlage's Amsterdam Exchange.

The recognition that the Gothic style harboured not only a soaring form of expression but, even more important, also contained the potential for the radical, constructive renewal of architecture, would have been impressed on Domènech by Eugene-Emmanuel Viollet-le-Duc's *Dictionnaire raisonné de l'architecture française* (1854–1868), which contained many digressions on this style. This particular understanding of the Gothic style also had its effect on Gaudí who sought logical and, in this respect, »natural« (buttress) constructions. This insight sent the two architects on different paths, but they were both obviously fascinated by the strange affinity between the Gothic buttress and the modern iron skeleton construction, for Viollet-le-Duc was of course not interested in reproduction and the mindless adherence to tradition. He was an innovator, with his eye on the building materials and techniques of his age.

At the same time, however, Barcelona's architects had also read what the English art critic John Ruskin had to say on architecture in *The Seven Lamps of Architecture* (1849): »... if indeed there be any profit in our knowledge of the past, or any joy in the thought of being remembered hereafter, which can give strength to present exertion, or patience to present endurance, there are two duties respecting national architecture whose importance it is impossible to overrate: the first, to render the architecture of the day, historical; and the second, to preserve, as the most precious of inheritances, that of past ages.« Later on in the book one encounters the following message: »...the architecture of a nation is great only when it is as universal and as established as its language; and when provincial differences of style are nothing more than so many dialects.« Ruskin's most famous book on architecture is entitled, *On the Nature of Gothic*. Ruskin was also important for his rejection of the unthinking, sentimental evocation of the old crafts. He countered this with a plea for a deliberately industrial art and an innovative rationalism in architecture.

Domènech first attracted attention with his competition design (done with Josep Vilaseca) for the Instituciones Provinciales de Instrucción Pública. The design already showed a surprisingly free interpretation of the Neo-Gothic style. He had examined all of the stylistic variations common at the time – Romanesque, and Catalan Neo-Gothic, as well as the Neo-Mudejar that played with Moorish motifs. His conclusion was unequivocal: it would be absurd to ape these in steel and cast iron. Instead an entirely new style had to be found, but – as Charles Moore put it a hundred years later – it had to be »an architecture with a memory«. In an article in the journal *La Renaixença* Domènech wrote: »Let us openly use those forms which impose new experiences and requirements upon us. We want to enrich them and give them expression through the inspiration of nature and the wealth of ornaments which the buildings of every age offer us.«

In 1904, three years after the »triumph of the four men« (Robert, Rusiñyol, Torres and Domènech i Montaner had been elected as representatives to the parliament in Madrid), which had been celebrated as an extraordinary occurrence, the fourth man gradually pulled back from political life. In the interim he had broken with the conservative Lliga Catalunya. He still played an active role in the foundation of the newspaper *El Poble Català* (The Catalan People), which first appeared on a weekly and then on a daily basis. It was from the circle around this newspaper that the radical, left-wing nationalist party, Esquerra Catalana, would eventually emerge. It might well have been the

Zeitschrift *La Renaixença*: »Laßt uns offen jene Formen anwenden, die neuere Erfahrungen und Bedürfnisse uns auferlegen. Wir wollen sie bereichern und ihnen durch die Inspiration der Natur und die Fülle der Ornamente, die uns die Bauten jedes Zeitalters bieten, zum Ausdruck verhelfen.«

1904, drei Jahre nach dem als außerordentliches Ereignis gefeierten »Triumph der vier Männer« (Robert, Rusiñol, Torres und Domènech i Montaner waren als Abgeordnete ins Madrider Parlament gewählt worden), zog sich der vierte allmählich aus der Politik zurück. Unterdessen hatte er mit der konservativen Lliga Catalunya gebrochen. Er beteiligte sich noch an der Gründung der zuerst wöchentlich, dann täglich erscheinenden Zeitung *El Poble Català* (Das Katalanische Volk), aus der schließlich die Partei der radikalen linken Nationalisten hervorging, die Esquerra Catalana. Vielleicht war er wirklich kein glanzvoller Redner – ein begabter Organisator war er, wie Mackay schreibt, jedoch ganz gewiß, aber auch jemand, der Mitstreiter und Mitarbeiter zu inspirieren verstand. Seine politische Karriere krönte er mit einem Buch, betitelt *Estudis politics*.

Domènech starb 1923 in Barcelona. Begraben wurde er in Canet de Mar, damals ein kleiner Fischerort nördlich der Hauptstadt.

Das Konzerthaus

Oriol Bohigas, einer der führenden Architekten Barcelonas in unseren Tagen und als Mitglied der Stadtregierung derjenige, der die atemraubende architektonische Erneuerung der katalanischen Metropole mit in Gang gesetzt hat, schreibt, daß Domènech i Montaner beim Palau de la Música Catalana »das modernistische Fieber ergriffen« habe. Eine schöne Umschreibung des Schöpfungsrausches, dem sich der Meister mit patriotischem Eifer ergeben hatte. Dennoch war er dabei ein Rationalist mit einem klaren Kopf, ein konstruierender Architekt geblieben.

Es ist selbstverständlich, daß sich das bautechnische Raffinement dieses einzigartigen Gebäudes nicht plakativ zu erkennen gibt. Das tragende Gerüst, das aus Stützen und Balken gebildete Stahlskelett, zeigt sich nicht. Domènech hat es, wie es sich in diesem Fall und in dieser Zeit gehörte, umkleidet, so wie Gottfried Semper es in seinem Buch *Der Stil* 1863 erläutert hatte: Wie der Körper der Kleidung bedürfe, so verlange die Konstruktion nach Verkleidung. Das Ornament, das dem kulturellen Anspruch Genüge tat, kam noch nicht aus der Fabrik, sondern entstand in den Werkstätten von Handwerksmeistern, deren Virtuosität im Lande einen großen Ruf hatte. Die Maurer Kataloniens zählte man zu den kühnsten Europas; dem Augenschein nach mußten den Keramikern und den Glasmalern ähnliche Epitheta gehört haben. Adolf Loos, der einige Jahre später heftige Zweifel an der Berechtigung des Ornamentes in den Bauten der Moderne zu hegen begonnen hatte, hätte hier vermutlich Beifall gespendet, denn Handwerk, Material, Herstellungstechnik und künstlerische Tradition waren hier noch eins.

Tim Benton nennt den Konzertsaal des Palau eine »verglaste Schale«. Die Wände sind in Glas aufgelöst, nirgendwo findet sich etwas Schweres, Lastendes. David Mackay umschreibt den Saal als eine »mit Stahl gerahmte Glasbox in einem Backsteingitterkäfig«. Der

Stahl ist das konstitutive Element, der Ziegelstein nur seine verschönernde Fassung. So wundert es wenig, daß die korpulente Säule, die die so überaus wichtige Ecke des Gebäudes im Altstadtgedränge so behäbig markiert, nicht massiv ist, sondern – wie die Säule daneben und die beiden in die Fassaden integrierten, ebenso dicken Halbsäulen – ein Hohlkörper, ein Raum ist mit Tür und Rundfenster, darin bis zur Verlegung des Eingangs noch die Eintrittskarten verkauft worden waren.

Wichtiger aber ist eine andere Funktion der vier Säulen. Denn mit den drei um die Ecke führenden schweren Korbbögen formulieren sie den vollständig verglasten ehemaligen Eingang zum Konzerthaus und die offene Halle der Vorfahrt, die die Ecke bildet und zugleich auflöst. Es scheint, als habe der Architekt mit dieser seltsamen asymmetrischen Inszenierung des Entrees auf die gegenläufige »Asymmetrie« der beiden verschieden langen und sehr repräsentativen Straßenfassaden angespielt. Beide Fassaden – die kurze, in sich symmetrisch aufgebaute Fassade an der Carrer Sant Pere més Alt, die so radikal wie geschickt an die neoklassizistische Kirche Sant Francesc anschließt, und die viel längere, in sich ebenfalls symmetrische, den Saal umschließende an der Carrer d'Amadeu Vives – waren ja bis zum behutsamen Umbau des Gebäudes die einzigen sichtbaren Außenseiten gewesen.

Doch die Säule, die die offene Ecke des Bauwerks so kolossal in sich versammelt, will ja auch (mit Werksteinbasis, Backsteinschaft, Mosaikschmuck) als der erdenschwere Stamm erscheinen, aus dem eine mächtige und figurenreiche Skulptur wächst. Ihr Bildhauer war Miquel Blay (1866–1936), einer der bekanntesten Künstler der Jahrhundertwende in Katalonien, der manche an den Belgier Constantin Meunier erinnert. Gestiftet hat sie Joaquim de Càrcer i d'Amat, Marquis von Castelbell, dem Orfeó Català. Ihr Thema ist – wie das Programm der Chorvereinigung – der Volksgesang der Katalanen. Verkörpert wird der »cançó popular catalana« durch eine Jungfrau von engelhafter Schönheit. Um ein findlingshaftes Felsgestein (den Montserrat) gruppiert, sind rechts die männlichen Sänger dargestellt (Bauer, Seemann, Alter und Jüngling), links die weiblichen (Bäuerin, Städterin, Alte und Mädchen), allesamt von oben wehrhaft beschützt durch den katalanischen Schutzpatron Sant Jordi in Helm und Harnisch, mit Schwert und Fahne. Die Künder des Volksgesanges sind auf einem mit Blatt- und Rankenwerk verzierten Balkon plaziert, der dem des Gebäudes vorgeblendet ist. So kann man hinter der Skulptur hindurch von einem Balkon zum anderen gelangen. Und eben dies war dem Architekten wichtig: daß die Fassade um die deswegen gerundete Ecke fließe und die Unterbrechung der Kante als Erhöhung erleben lasse.

Doch die Dramaturgie dieser Ecke endet nicht mit der Skulptur. Über einem zierlichen Spitzbogenmotiv, das hinter ihr ansetzt, erstreckt sich zuerst einmal eine durch kein Dekor unterbrochene Backsteinfläche. Doch darüber ist ein neues Ereignis arrangiert, dort sitzt in einem Backsteinkranz das mosaizierte Emblem des Orfeó Català (von Marius Maragliano) mit dem gelb-rot gestreiften Wappen und der Inschrift »Palau de la Música Catalana«. Worauf als Krönung ein rund überkuppelter, mit Mosaik geschmückter runder Eckturm kommt (der übrigens seit den fünfziger Jahren eine viel impo-

case that he was not a brilliant orator, but as Mackay has noted, he certainly possessed great organizational talents. Moreover, he was definitely somebody who knew how to inspire the people around him. He crowned his political career with a book entitled *Estudis politics*.

Domènech died in 1923 in Barcelona. He was buried in Canet de Mar, which at the time was a small fishing village north of the capital. As a young man he had built the Casa Roura there and later worked on the restoration of the Santa Florentina castle.

The concert house

Oriol Bohigas, one of contemporary Barcelona's leading architects and – as a member of the municipal government – one of the figures responsible for the breathtaking architectonic renewal of the Catalan capital, once noted that with the Palau de la Música Catalana, Domènech i Montaner »was seized by the Modernistic fever«. This is a nice description of the intoxication of creation to which the master succumbed with patriotic enthusiasm. Nevertheless, during this process he remained a rationalist with a cool head, a constructing architect.

Naturally, this unique building does not broadcast the finesse of its engineering. Its load-bearing framework – a steel skeleton of supports and beams – cannot be seen. In 1863 Gottfried Semper had already argued in his book *Der Stil*, that in the same way as a body needs clothing, a construction needs to be dressed, and this building was dressed by Domènech in a manner appropriate to it and to its era. The ornamentation which fulfilled contemporary expectations was not yet produced in factories but rather was created in the workshops of master craftsmen whose virtuosity was famed throughout Catalonia. Some of Europe's most adventurous bricklayers could be found here and, to judge by appearances, the same epithet can be applied to its ceramics craftsmen and glass painters. A few years later, Adolf Loos began to voice serious doubts about the justification of ornamentation for modern buildings, but he would probably have given his approval here: craftsmanship, material, manufacturing technique and artistic tradition were still one.

Tim Benton called the Palau's concert hall a »glass shell«. The walls dissolve into glass, nowhere is there anything heavy or oppressive. David Mackay has described the hall as a »steel-framed glass box inside of a brick-grid cage«. Steel is the constitutive element. The brick only provides its enhancing setting. It should come as no surprise, therefore, that the corpulent pillar which makes such a solid impression at the extremely important corner where the building is crammed into the old town, is actually not solid at all. Instead, – like the pillars beside it and the two half-pillars integrated into the façade – it has a hollow body. It is a room with a door and a rounded window, from which the concert tickets were sold until the entrance was placed elsewhere.

There is, however, a more important function performed by these four pillars: together with the three heavy basket arches which lead around the corner they serve to formulate both the completely glassed-in former entry to the concert house and the open hall of the entrance area. The latter creates this corner, while at the same time dissolving it. With the strangely asymmetrical staging of the entrance, the architect was probably alluding to the opposing »asymmetry« of the two highly impressive street façades of differing lengths. Until its careful renovation, the building's only visible outer walls were these two façades: the short one on the Carrer Sant Pere més Alt which is in itself symmetrical and has been connected in a radical and skilful manner to the Neo-Classical church, Sant Francesc, and the much longer façade on the Carrer d'Amadeu Vives, which is also in itself symmetrical and encompasses the concert hall.

Yet with its stone base, brick shaft and mosaic decoration, the colossal pillar which gathers up the building's open corner, must also be seen as an earthbound stem sprouting a magnificent and richly detailed sculpture. The sculptor was Miquel Blay (1866–1936). At the turn of the century, he was one of the most well-known artists in Catalonia, and his work has reminded some people of the Belgian sculptor, Constantin Meunier. The sculpture was donated to the Orfeó Català by Joaquim de Càrcer i d'Amat, Marquis of Castelbell. Its theme – like that taken up by the choral association – is the Catalan folk-song. The »cançó popular catalana« is embodied as a virginal maiden of angelic beauty. Grouped to the right of a boulder (the Montserrat) are the male singers (farmer, sailor, old man and a youth) and to the left are the female singers (farmer's wife, town-dweller, old woman and girl). Stalwart protection from above is provided by the patron saint of Catalonia, Sant Jordi, who is fitted out with a helmet and armour, sword and flag. The harbingers of the folk-song have been placed on a balcony which has been decorated with leaves and vines, and set in front of the building's balcony. This means that one can pass through the sculpture from one balcony to the next. It was exactly this which was important to the architect: the façade should flow around the corner which had been rounded for this reason and the interruption in the edge should be experienced as an elevation.

But the dramaturgy of this corner does not end with the sculpture. A plain brick expanse stretches over a delicate pointed arch motif which begins behind this corner. Although the brickwork is at this point still unadorned, above it a new event has been arranged: the emblem of the Orfeó Català, with its yellow and red striped coat of arms and the inscription »Palau de la Música Catalana«, has been rendered in mosaic (Marius Maragliano) and wreathed in brick. The coping is in the form of a rounded corner tower which has been decorated with mosaic and topped with a rounded dome. (It was not until the 1950's incidentally, that this tower replaced a much more impressive coping with an iron-framed, serrated glass amphora.) Yet the real high point does not occur here either but rather on the gable beside it, high above the Carrer Sant Pere més Alt, at the termination of the symmetrically structured narrow façade which rises in such an ingenious manner. At the bottom of this façade are the two solid basket arches of the entrance area. It then continues on to the balcony. The latter encloses the entire building on both of its street fronts, much like the ledge of a pedestal. The balcony also forms a deep colonnade, articulated by two rows of columns. Above the capitals and decorative linking elements, four of the seven columns in the first row are transformed into angular

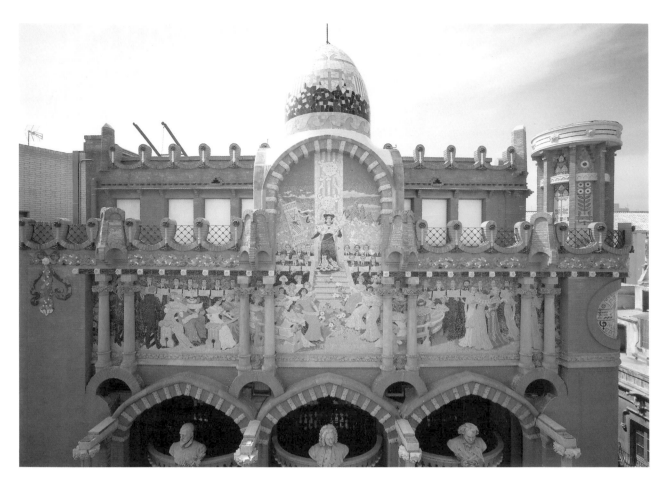

7. Lluís Domènech i Montaner, Palau de la Música Catalana, Barcelona, 1905–08. Detail der Südostfassade (Photo: Hisao Suzuki)

7. Lluís Domènech i Montaner, Palau de la Música Catalana, Barcelona, 1905–08. Detail of the south-east façade (Photo: Hisao Suzuki)

santer gewesene Krone mit einer eisengefaßten, gezackten Glasamphore ersetzt). Nun denn: Der wahre Höhepunkt ereignet sich auch hier nicht, sondern am Giebel daneben, hoch über der Carrer Sant Pere més Alt, als Abschluß der symmetrisch aufgebauten und raffiniert sich steigernden schmalen Fassade. Sie beginnt unten mit den beiden behäbigen Korbbögen der Eingangspartie und setzt sich im Balkon fort, der das ganze Gebäude an seinen beiden Straßenfronten wie ein Sockelgesims umfaßt und eine tiefe, von zwei Säulenreihen gegliederte Kolonnade bildet. Vier der insgesamt sieben Säulen der vorderen Reihe gehen, über den Kapitellen und dekorierten Zwischengliedern in eckige Pfeiler verwandelt, in verwirrend geformte Konsolen über. Die drei Säulen dazwischen hingegen tragen, oben an rund vorkragende Balkonbrüstungen gelehnt, die (von Eusebi Arnau in Stein gehauenen) Büsten dreier Komponisten: Giovanni Pierluigi Palestrina, Johann Sebastian Bach und Ludwig van Beethoven (dessen Verehrung mit einer Büste im Saal noch eine Steigerung erfährt). Richard Wagner hingegen ist um die Ecke plaziert; denn dorthin hat der Architekt die Eingangsfassade mit zwei Achsen herumgezogen: gleiche Fassade für denselben Inhalt (für Eingang und Treppenhaus). Sie erscheint noch einmal ganz hinten am Bühnenhaus und bildet somit eine Fassung für die lange, den Saal umschließende Front.

Alle Säulen hier auf dem Balkon setzen mit einer Steinbasis an, alle sind in einem Kranzkapitell aus keramischen Blumen versammelt, ihre Schäfte sind über und über mit farbig leuchtenden Mosaiken überzogen, geometrischen Dessins im unteren, stilisierten Blumen in den zwei oberen Dritteln. Zusammen mit den farbig geschmückten Fenstern wirken sie wie ein zweifacher Filter, der das Licht leicht getönt ins Innere passieren läßt.

Welch eine Vorbereitung für die apotheotische Darstellung der stolzen Hausherren! Sie spielt sich unter einer zapfenförmigen, mit Fayencen ausstaffierten Kuppel ab, in einem ausladenden szenischen Mosaik, das das ganze obere Stockwerk bedeckt und sich unter der Kuppel aufwärts wölbt. Lluís Bru (1868–1952) hat darauf den 1891 gegründeten Orfeó Català porträtiert und mit allerlei Symbolen ausgestattet: an die dreißig Damen in langen hellen Kleidern, ebenso viele Männer in schwarzen Anzügen, Noten in den Händen. Über ihnen, auf einem Thron am Ende einer Treppe posiert die Patronin des Chores (sowie der katalanischen Textilindustrie) mit einem Spinnrocken in der Hand, der ja auch das Symbol der Volksmusik in Katalonien ist. Vor dem hellblauen, weiß bewölkten Hintergrund erscheinen die schroffen Felsspitzen des »gesägten Berges«, des heiligen Montserrat. Gerahmt wird das stolze Bild von einem rosengeschmückten Mosaikgesims und einem backsteinernen Schleifenfries.

Schwer, all das unten auf der Straße mit bloßem Auge zu erfassen. Aber nicht viel leichter, die längere Fassade an der Carrer d'Amadeu Vives zu lesen, trotz ihrer großzügigeren Gliederung über dem durchgehenden langen Balkongesims über dem Sockelgeschoß. Den Hauptteil bildet der eigentliche Inhalt des Gebäudes, der Konzertsaal, mit dem ruhigen Gleichmaß der großen Fenster in drei Reihen übereinander. Alles ist aus dem Inneren, aus dem Grundriß entwickelt, die langen geraden wie die kurzen gebogenen Balkons, die großzügigen Arkaden vor den kleinen Nebensälen und Aufenthaltsräumen (die damit ihre fröhliche orientalische Pracht begründen), die Reihung und die Form der Fenster und ihr Sitz in der Wand. Selbst die Vielfalt des eigenwilligen, nur allmählich zu entschlüsselnden Rhythmus der Fassade und ihres turbulenten Reliefs ist gestaltete Funktion.

buttresses leading to confusingly formed consoles. The three columns which lie between them, however, are crowned by the busts of three composers. Leaning against the round projecting balcony balustrades, and chiselled out of stone by Eusebi Arnau, the busts depict Giovanni Pierluigi Palestrina, Johann Sebastian Bach and Ludwig van Beethoven. (The homage shown to the latter is intensified with a bust in the concert hall.) In contrast, Richard Wagner is placed around the corner, the point to which the architect pulled around the entrance façade with its two axes. There is the same façade for the same contents (entrance and stairwell). It appears once more at the very back, at the fly tower, and thereby provides a setting for the long front encompassing the concert hall.

All of the columns here on the balcony have a stone base; all of their capitals are wreathed with ceramic flowers, their shafts are completely covered with colourful, shining mosaic – geometric designs on the bottom third and stylized flowers on the remaining two thirds. Together with the colourfully decorated windows, they act as a double filter, allowing softly toned light to pass through into the interior.

What a preparation for the apotheotic depiction of the proud house-owners. It takes place under the cone-shaped, faience-covered dome, and is presented in a sweeping, scenic mosaic which covers the entire upper storey and curves upwards underneath the dome. Lluís Bru (1868–1952) portrayed the Orfeó Català, founded in 1891, and he included all sorts of symbols in his depiction. There are close to thirty women in long pale dresses and as many men in black suits holding music. Posed above them, on a throne at the end of a staircase, is the choir's patron (and the patroness of the Catalan textile industry) with a distaff in her hand, which is of course also the symbol of Catalan folk-music. The craggy peaks of the »serrated mountain«, the holy Montserrat, can be seen in front of the pale blue and cloudy white background. This impressive picture is framed by a ledge decorated with mosaic roses and by a brick frieze.

It is difficult to see all of this with the naked eye when one is standing down on the street. It is not much easier, however, to read the long façade on the Carrer d'Amadeu Vives, and this, despite the fact of its generous articulation on the continuous balcony ledge above the socle storey. The actual contents of the building forms the main section – the concert hall. Here, a calm regularity is evident in the way that the large windows have been placed over each other in three rows. Everything develops from the interior, from the ground plan – the long, straight balconies as well as the short, curved ones; the spacious arcades in front of the small side rooms and day rooms (which is the reason for their cheerful Oriental splendour); and the sequence and shape of the windows as well as their position in the wall. Even the diversity of the unorthodox façade – whose rhythm can only be deciphered bit by bit – and its turbulent relief work is formed, functional expression.

A quotation from Gottfried Semper (Kleine Schriften, 1884) suggests itself here: »Wherever man decorates, his more or less deliberate actions only serve to emphasize more clearly the natural properties of the object which he is decorating.« One is also reminded of Louis Sullivan, and his clever slogan, »form follows function«, whereby the form of a building – as well as its ornamentation, which is ennobled by its meaning – must be an expression of its function. Although the slogan would become worn out through its superficial appropriation by others, it can nonetheless also be considered as the password of modern architecture. Domènech i Montaner's Palau façade is the exaggerated representation of the interior, whose most important component is the concert hall. During the day sunlight falls through the large, coloured windows, and when it is dark the magnificently illuminated hall sparkles its message to the world outside.

The concert hall

The hall's long, rectangular shape guarantees excellent acoustics at its best, this shape cannot be surpassed. The hall does, however, have a small deviation: towards the podium it becomes a bit more narrow. The hall reaches from the second to the fifth storey. There are stalls, a first circle, and a second circle which extends up into the next storey. Not only the room's shape is classic, so too is its seating, covered in red upholstery, and the boxes on its sides. What is utterly unique, however, is the ornamental temperament and the opulent imagination with which Lluís Domènech i Montaner has prepared this architectonic feast for the music and the audience – and, in the process, leading Modernisme to its high point.

One senses the room. One enjoys, without immediately noticing the unusual atmosphere. The eyes race through the wealth of ornamental and sculpted decorations which often carry symbolic meanings. One is overpowered and succumbs to the mood created by the incomparable light which is charged with the colours that are everywhere. Sometimes it seems as if one is swimming in this light. Very slowly one begins to read the room – the glass painting on the windows, the wealth of colours and figures on the ceiling's ceramic relief and its longitudinal pleat, the magnificent mosaic columns on the sides. These columns are connected to each other by flat, pointed arches. They carry the weight of the ceiling with broad, projecting ribbed vaults which emerge out of ceramic baskets and reach high above the capitals. While the ribs and decoration of these vaults recall peacocks doing cartwheels, in their construction they are reminiscent of flat, Gothic ribbed vaulting (and in particular the closely ribbed vaulting at the Wells Cathedral chapterhouse in England).

The interior undergoes its apotheosis in the glazed right-angle which has been placed in the ceiling, high above the heads of the audience. The glass has been painted in tones of blue and yellow-brown and forms a frustum at the centre, before turning into a voluminousdrop. This is not a chandelier which might still remind one of the Renaissance or the Baroque but rather an integrated and highly individual form of lighting.

We know that the architect conceived of the hall and the podium as one room, so that the music would evoke a sense of community between the musicians and the audience. That is why the podium projects in a slight curve, and since the renovation it can also be enlarged at the front. (This has also allowed for a greater range of variations at the rear.) Yet, at the same time, the stage also effects a massive separation, for it is a sculptural event of thunderous drama.

Es liegt nahe, Gottfried Semper zu zitieren, der in den *Kleinen Schriften* von 1884 notiert: »Wo der Mensch schmückt, hebt er nur mit mehr oder weniger bewußtem Thun eine Naturgesetzlichkeit an dem Gegenstand, den er ziert, deutlicher hervor.« Man wird aber auch an Louis Sullivan erinnert, an seinen gescheiten, durch vordergründigen Gebrauch lädierten Slogan »form follows function«, der zum Losungswort der Modernen Architektur wurde und dem zufolge die Form eines Gebäudes – aber auch sein durch Bedeutung geadelter Schmuck – Ausdruck seiner Funktion zu sein hat. Domènech i Montaners Palau-Fassade ist das überhöhte Abbild des Inneren, dessen wichtigster Bestandteil der Konzertsaal ist. Tags fällt das Licht der Sonne durch die großen bunten Fenster hinein, im Dunkeln funkelt der festlich erleuchtete Saal seine Botschaft nach außen.

Der große Saal

Der Saal hat einen langgestreckten rechteckigen Zuschnitt, eine akustisch bewährte, in ihren edelsten Exemplaren unübertroffene Form, hier allerdings mit einer kleinen Abweichung: Der Saal wird zum Podium hin ein wenig schmaler. Er reicht vom zweiten bis ins fünfte Obergeschoß: Parkett, erster Rang, bis ins nächste Stockwerk hinauf reichender zweiter Rang. So klassisch wie die Form des Raumes, so klassisch das rot bezogene Gestühl und die Logen an den Seiten. Ganz von eigener Art jedoch sind das ornamentale Temperament und der Einfallsreichtum, mit dem Lluís Domènech i Montaner der Musik und ihrem Publikum dieses architektonische Fest bereitet – und den Modernisme dabei auf seinen Höhepunkt geführt hat.

Man spürt den Raum. Man genießt, ohne es gleich zu bemerken, die außergewöhnliche Atmosphäre. Die Augen hasten durch den Reichtum an ornamentalem und plastischem Schmuck von oft symbolischer Bedeutung. Man ist überwältigt und ergibt sich der Stimmung, die das unvergleichliche, ringsum von Farben aufgeladene Licht erzeugt, in dem man bisweilen zu schwimmen scheint. Ganz langsam beginnt man, den Raum zu lesen – die Glasmalerei der Fenster, das farben- und figurenreiche keramische Relief und das Längsplissee der Decke, die Pracht der mosaizierten Säulen an den Seiten. Diese Säulen sind untereinander mit flachen Spitzbögen verbunden. Sie nehmen die Deckenlast mit breit ausladenden, hoch über den Kapitellen aus keramischen Körben emporwachsenden Gewölbeschirmen auf, die mit ihren Rippen und dem Dekor an radschlagende Pfauen erinnern, mit ihrer Konstruktion aber auch an flache gotische Schirmgewölbe (und da besonders an so dicht gerippte wie im Kapitelhaus der Kathedrale zu Wells in England).

Seine Apotheose erfährt das Interieur in dem gläsernen Rechteck, das hoch über den Köpfen in die Decke eingelassen ist, eine in blauen und gelb-braunen Tönen gehaltene Glasmalerei, die in der Mitte einen Kegelstumpf bildet und dann in einen voluminösen Tropfen übergeht. Das ist kein Kronleuchter, der noch eine Erinnerung an die Renaissance oder das Barock weckte, sondern eine integrierte Lichtgestalt von gänzlich eigener Art.

Man weiß, daß der Architekt Saal und Podium als einen gemeinsamen Raum gedacht hat, so die Gemeinschaftlichkeit der Musizierenden mit den Zuhören-den beschwörend und die alles verbindende Musik. Deshalb ragt das Podium, das seit dem Umbau nach vorn erweitert werden kann (und nun auch hinten einen größeren Variantenreichtum zuläßt), mit einer leichten Rundung vor. Man bemerkt aber auch eine gewaltige Trennung durch den Bühnenrahmen, ein skulpturales Ereignis von donnernder Dramatik.

Was dort nicht alles geschieht! Rechts, über einem Busch von Blättern und Rosen und zwischen zwei dorischen Säulen, erhebt sich die Büste Beethovens. Über seinem Haupt wallt eine Wolke, die von oben, wo drei (Wagnersche) Walküren auf schnaubenden, sich wild gebärdenden Rössern durch die Lüfte galoppieren, hervorquillt. Die Jungfrauen in Helm und Rüstung schwingen Lanzen und Schilde und lassen die Zügel hängen. Links gegenüber ragt aus einer von Rosengirlanden umschlungenen Jungfrauengruppe die Büste Anselm Clavés auf. Hinter ihm wächst ein Baum empor und streckt seine buschige Krone bis an die Decke. Der Bildhauer spielte ganz offenbar auf ein Lied von Clavé an, »Die Maiblumen«, darin ein Mädchen mit goldenem, zu dicken Zöpfen geflochtenem Haar unter einer Weide sitzt – das sei ein Anblick, so erfrischend wie eine kristallene Quelle, welche deshalb, seitwärts in den Saal gerichtet, als ein wasserspeiendes Gesicht dargestellt ist. Beethovens Blick trifft auf eine der Jungfrauen, Clavé hat den Wolkenzipfel gegenüber im Auge: ein seltsames, monumental ins Leere gehendes Zwiegespräch. Eben dies sollte jedoch mit Pau Gargallos Skulpturen bekräftigt werden: die vom Orfeó Català erstrebte gleichberechtigte Pflege der Lieder des Volkes und der klassischen Musik der Meister. Und beides war doch auch Ursprung und Ziel des Modernisme: Tradition und Fortschritt, alte und neue Kultur in freundlicher Umarmung.

Nicht genug damit, verlangt nun auch die runde Rückwand des Podiums Aufmerksamkeit. Denn auf ihr ist eine Huldigung an die Musik dargestellt: Achtzehn Damen blasen auf Flöten und Dudelsack, greifen in Zithern und Sistern, Lyren und Harfen, schlagen Trommeln und die Triangel, klappern mit Kastagnetten, spielen Geige oder gebrauchen ihre Stimme. Lluís Bru und Eusebi Arnau, die Künstler, hatten dabei einen für den Jugendstil typischen Einfall: Bis zur Taille sind ihre Figuren eins mit der Wand; darüber treten sie, mit ihren Instrumenten hantierend, als Hochreliefs hervor. Die Kleider zitieren mit ihren heraldischen Dessins die Provinzen Kataloniens. In der Höhe leicht gegeneinander versetzt, sind sie auf dem Scherbenmosaik der Wand mit Blumengirlanden von ähnlicher Art verbunden, wie sie fast alle Fenster zieren. In der Nische zwischen ihnen, von zwei Säulenpaaren gesäumt, die den Weg auf die Hinterbühne öffnen, erkennt man das katalanische Wappen, auch dies ein Mosaik; seitwärts steht, als könne der Bau- und Hausherr nicht genug daran tun, seinen Stolz zu zeigen, die Standarte des Orfeó Català mit Schild, Helm und Lyra (nach einem Entwurf von Antoni Maria Gallissà).

Darüber thront, wie auch anders, die Orgel. Hinter dem gotisierenden Holzgeländer wirkt ihr Prospekt moderner als fast alles andere in diesem der Moderne gewidmeten Bau: symmetrische Anordnung, klare, leicht beschwingte Konturen, in der Mitte eine mit der Brüstung korrespondierende Holzbrosche. Das 1908 geweihte Werk stammt von der Orgelbaufirma Eberhard Friedrich Walcker & Co. aus dem württembergischen Ludwigsburg, deren Tradition bis ins 18. Jahr-

The things that go on there! On the right, between two Doric columns, a bust of Beethoven rises above a bush of leaves and roses. A cloud over his head has floated down from above, where three (Wagnerian) Valkyries gallop through the air on their wild, snorting horses. Outfitted with helmets and armour, they have dropped the reins and are swinging lances and shields. In contrast, on the opposite left-hand side a bust of Anselm Clavé stands amidst a group of maidens adorned with rose garlands. There is a tree growing behind him, whose bushy crown reaches to the ceiling. The sculptor was obviously alluding to a song by Clavé – »The May Flowers« – in which a girl with golden hair which has been plaited into thick braids sits under a willow. This is said to be a sight as refreshing as a crystal mountain spring. This is why the face which is looking sideways into the room is spouting water. Beethoven is looking at one of the maidens and Clavé has his eyes on the wisp of the cloud across from him. It is a strange, aimless dialogue. The intention of Pau Gargallo's monumental sculptures, however, was to lend support to the Orfeó Català's desire to cultivate equally the songs of the people and the classical music of the masters. And both were also the origin and the goal of Modernisme: tradition and progress, old and new culture in a friendly embrace.

But this is not all. The curved back wall of the podium also demands attention, for it too presents a homage to music. Eighteen women blow on flutes and a bagpipe, strum zithers, lyres and harps, beat drums and a triangle, rattle castanets, play the violin and use their voice. The artists Lluís Bru and Eusebi Arnau had an idea for this display which was typical for Jugendstil: to their waists the figures are one with the wall, and then they become three-dimensional high reliefs and step forward, busy with their instruments. The heraldic designs on the dresses refer to Catalonia's provinces. Higher up, staggered slightly against each other, they reappear in mosaic and are linked to each other by garlands of flowers, similar to the type which decorate almost every window. In the niche between them, flanked by two pairs of columns which lead to the rear of the stage, one recognizes the Catalan coat of arms. This too is a mosaic. And – almost as if the house-owner could not do enough to show his pride – standing sideways is the standard of the Orfeó Català, with shield, helmet and lyre (after a design by Antoni Maria Gallissà).

Throning above it – how could it be any different – is the organ. Behind its Gothic-style wooden railing it appears more modern than almost anything else in this building dedicated to modernism. It has a symmetrical arrangement, clear, slightly animated contours, and a wooden brooch at its centre which corresponds with the balustrade. Dedicated in 1908, it was built by the German organ manufacturer, Eberhard Friedrich Walcker & Co. in Ludwigsburg. The firm's tradition reaches back to the 18th century and its organs became famous for their »clear silver tone... of a grand, holy character«. (Barcelona would subsequently recall this and had the organ for the World Exhibition in 1929 built there.) The gallery on either side of the organ is a practical addition. Singers and musicians can stand here, as well as members of the audience who have not found a seat in the concert hall.

There is still much more to note in this room. Much which has been created by the inventive imagination of the architect and artists – railings, tiles, chandeliers (which wreath the columns in the hall), composer medallions, memorial plaques chiselled out of stone as well as the muses' winged steeds, flying off of the walls above the second circle. The double Pegasus could not be missing!

All of this was only possible, however, because Domènech could find and inspire craftsmen of exceptional abilities for his new architecture. Amongst these was the ceramic artist Casany from Manises, whose experience with texture, colour and form was an important, stimulating influence for the architecture. The craftsmen also included highly talented cabinetmakers, glass painters and metalsmiths. »It was only through such collaboration«, wrote the architectural historian, Ignasi de Solá-Morales i Rubió (Der Architekt, 9, 1985), »that it was possible to create the brilliant floral decorations and the amazing designs which are so distinctive to the architecture of this period.«

The entrance

The reception provided by Lluís Domènech for the visitor who enters from the Carrer Sant Pere més Alt is at first simple and then progressively more elaborate. He took care that the transition from the street to the interior was not an abrupt one. That is why the guest at first has his way lit by candelabra resembling street lamps, and why one encounters the same materials inside as have been used on the exterior – red brick, grey stone, glass and ceramic – as well as the same ornaments. These include, above all else, flowers. flowers in the shape of buds, bouquets, wreaths, garlands and other arrangements; flowers in windows and doors, on lights and columns, walls and ceilings, balustrades and sculptures. Sometimes they are true to life and sometimes they are stylized and geometrical abstractions. The flower is the favoured motif of the Catalan Renaissance, and appears constantly in the poetry and the painting as well as in the architecture of Modernisme.

Until the 1980's the ground storey served a variety of purposes. The music library could be found here. (This was where the foundation stone was laid on 23 April 1905, on the Feast of Saint Jordi. The stone contains the text of the speech held by Joaquim Cabot in the presence of 185 choir members and 1358 members of the association.) The ground storey also contained a café, a room for reading music, a general reading room, a conference room and the administration. Finally, a rehearsal room was located across from the main entrance, directly underneath the semi-circular stage.

Apart from the entrance, the rehearsal room is the only room which has been preserved. Everything else has had to make way for a an agreeably spacious and original concept, the result of an intervention which was as refreshing as it was careful. The architect was Oscar Tusquets from Barcelona.

Extensive studies had already been carried out in 1983 by Tusquets and Lluís Clotet, his partner at the time. He then took six years for the sorely needed restoration of the venerable building and for the courageous conversion of its internal ordering. For the time being his most important idea was to leave the old southern entrance untouched, but to place the main

hundert zurückreicht und deren Orgeln einmal für den »hellen Silberton… von großem heiligen Charakter« gerühmt wurden. (Barcelona hatte sich dessen später wieder erinnert und dort auch die Weltausstellungsorgel von 1929 bauen lassen.) Die Empore beiderseits der Orgel ist eine praktische Beigabe. Sie taugt für die Postierung von Sängern und Musikern, aber auch für das Publikum, das im Saal keinen Platz mehr findet.

Es gäbe in diesem Raum noch viel von dem zu bemerken, was die erfinderische Phantasie des Architekten und der bildenden Künstler hervorgebracht hat – Geländer, Fliesen, Kronleuchter (die die Säulen im Saal schräg umkränzen), Komponisten-Medaillons, aus Stein gehauene Erinnerungstafeln und auch die geflügelten Musenrösser, die über dem zweiten Rang aus den Seitenwänden flattern: der doppelte Pegasus, wie hätte er fehlen dürfen!

All das war jedoch nur möglich, weil Domènech Handwerker mit außerordentlichen Fertigkeiten für seine neue Architektur finden und begeistern konnte. Er gewann den Keramiker Casany aus Manises, der mit seinen Erfahrungen in Textur, Farbe und Form wichtige Anregungen für die Architektur beisteuerte, dazu hochtalentierte Möbeltischler sowie Glas- und Metallhandwerker. »Nur durch diese Zusammenarbeit war es möglich«, schrieb der Architekturhistoriker Ignasi de Solá-Morales i Rubió (*Der Architekt*, 9, 1985), »die Brillanz des floralen Dekors und des erstaunlichen Designs unverwechselbar für die Architektur dieser Periode herzustellen.«

Der Eingang

Lluís Domènech i Montaner hatte dem Besucher, wenn er von der Carrer Sant Pere més Alt eintrat, einen zunächst einfachen, sich alsbald steigernden Empfang bereitet. Er hatte darauf geachtet, daß der Übergang von der Straße ins Innere nicht abrupt geschehe. Deshalb leuchteten dem Gast zuerst Kandelaber den Weg, die Straßenlaternen ähnelten, deshalb begegnet man innen den gleichen Materialien wie außen, rotem Ziegelstein, grauem Werkstein, Glas und Keramik, auch den gleichen Ornamenten, darunter immerzu und überall Blumen, Blumen in Gestalt von Blüten, Sträußen, Kränzen, Girlanden und anderen Gebinden, Blumen in Fenstern und Türen, an Leuchten und Säulen, auf Wänden und Decken, an Brüstungen und in Skulpturen, manchmal nachgebildet, manchmal stilisiert und geometrisch abstrahiert. Die Blume ist das bevorzugte Motiv der katalanischen Renaissance, und so figuriert sie auch in den Dichtungen des Modernisme, in der Malerei wie in der Architektur.

Bis in die achtziger Jahre diente das Erdgeschoß vielfältigem Gebrauch. So befanden sich hier die Musikbibliothek – darin der am 23. April 1905, am Fest des Heiligen Jordi gesetzte Grundstein, in dem auch der Text verewigt ist, den Joaquim Cabot damals in Gegenwart von 185 Choristen und 1358 Vereinsmitgliedern vorgetragen hatte –, ein Café sowie ein Notenleseraum, ein allgemeiner Leseraum, ein Konferenzraum und die Verwaltung. Gegenüber dem Haupteingang, genau unter der halbrunden Bühne, hatte man schließlich den Probensaal untergebracht.

Der Probensaal ist der einzige Raum, der im Erdgeschoß außer dem Eingang erhalten geblieben ist. Alles andere ist einer Konzeption von angenehmer Großzü-

gigkeit und Originalität gewichen, Ergebnis eines Eingriffs von ebenso erfrischender wie behutsamer Art. Der Architekt war Oscar Tusquets aus Barcelona.

Tusquets hatte schon 1983 zusammen mit seinem damaligen Partner Lluís Clotet ausführliche Studien gemacht, sich schließlich sechs Jahre Zeit für die dringlich gewordene Restaurierung des ehrwürdigen Bauwerks, zugleich für den couragierten Eingriff in seine innere Gliederung genommen. Sein wichtigster Gedanke war zunächst, den alten Eingang im Süden zwar nicht anzurühren, den Haupteingang aber in die Nordostecke des Gebäudes zu verlegen – eine nicht nur architektonische und organisatorische, sondern auch städtebauliche Tat mit der wundervollen Konsequenz, daß das Konzerthaus nun einen Eingangshof – und die Stadt einen Platz gewonnen hat. »Ein Glück für den Musikpalast«, sagt Tusquets, der »eigentlich dazu geboren war, ein freistehendes Gebäude zu sein, es aber verleugnen mußte.« Am Ende hat der Palast nun zwei ebenbürtige Eingänge: den hinzu erfundenen neuen – und den alten, der kürzlich mit zwei sehr grossen, zur Hälfte nach außen reichenden und dort mit Kupfer gedeckten Drehtüren vervollkommnet wurde. Haupteingang ist für jedermann fortan derjenige, der ihm am liebsten oder am nächsten ist.

Tusquets entfaltete eine mutige Phantasie, und auch nur so hatte die Operation gelingen können. Zuerst machte er sich an die niemals vollendete neoklassizistische Kirche Sant Francesc, die nach einem Entwurf des Architekten E. P. Cendoya Seite an Seite mit dem Palau de la Música errichtet worden war. Er verkürzte den merkwürdig proportionierten Bau um etwa ein Drittel (auf drei Joche), stockte ihn ein wenig auf und gab ihm endlich mit einer neuen Apsis einen würdigen Abschluß. Im Inneren erinnert er mit einer Spiegelwand an die alte Länge. Dort aber, wo das Presbyterium der Kirche gestanden hatte, öffnete er nun den Hof für den neuen Eingang – und gab so auch den Blick frei auf die westliche Konzerthaus-Fassade, die Domènech ähnlich gebaut hat wie die östliche Straßenfassade, wenngleich ohne zu hoffen, daß sie sich je den Augen zeigen werde.

Der hinzugewonnene kleine Platz wird freilich nicht nur von der Apsis, sondern auch von einem dem Palau angefügten neuen Flügel gegenüber eingefaßt. Dieser mündet in einen Turm, der das neue Zeichen ist. Er präsentiert sich, fast nicht zu übersehen, durch die schmale Gasse Ramon Mas zur Via Laietana hin, der man mit ihrer merkwürdigen X-förmigen Erweiterung ansieht, wie brachial sie einst in das mittelalterliche Stadtgefüge gehauen worden ist. Tusquets' Eckturm ist keine willkürliche Erfindung, sondern die geistreiche Reverenz an den runden Erker, der das Eckhaus vorn an der Hauptstraße markiert. Selbst den pilzförmigen Sockel mit dem aus Stein geschlagenen Rippenkranz kann man als fernen Gruß an Domènechs Säulenpilze verstehen – genauso wie der transparente Turmaufsatz aus Stahl und Glas und die distinguierte Durchbildung der Backsteinfassaden auf den alten Bau hinweisen. Auch das Relief am Eingang zu dem neuen Flügel für Verwaltung, Bibliothek, Archiv sowie Sitzungs- und Probenräume ist eine Jugendstil-Paraphrase, die, wie anders, dem Orfeó Català gewidmet ist; man kann es unter den beiden im Grase hockenden Jungfrauen und den singenden Gesichtern – vier Frauen, vier Männer – auch lesen. Kein Zweifel: alles Hinzugefügte als Hommage à Domènech i Montaner zu verstehen –

8. Oscar Tusquets und Lluís Clotet, Tusquets, Díaz &
Assoc., Erweiterung des Palau de la Música Catalana,
Barcelona, 1983–89. Turm in der Westecke des Ge-
bäudes. (Photo: Hisao Suzuki)

8. Oscar Tusquets and Lluís Clotet, Tusquets, Díaz &
Assoc., extension of the Palau de la Música Catalana,
Barcelona, 1983–89. Tower at the west corner of the
building. (Photo: Hisao Suzuki)

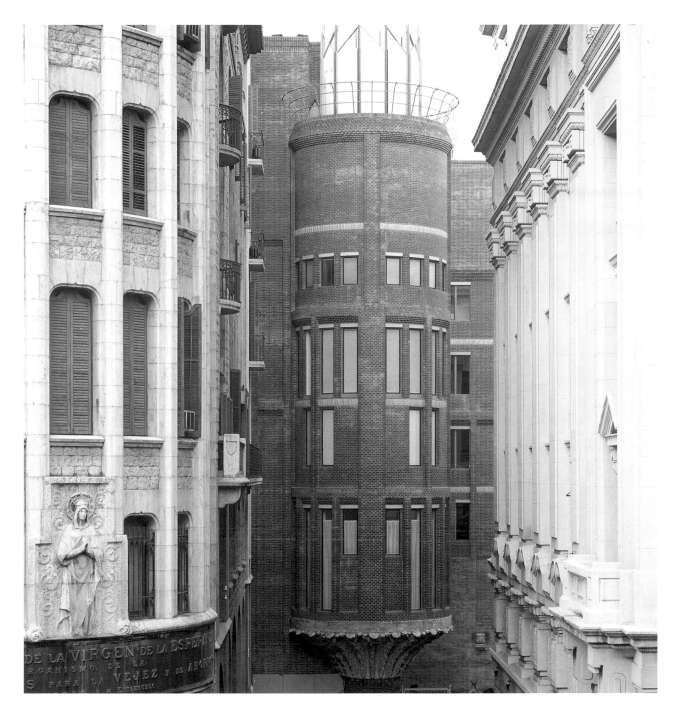

entrance in the building's north-eastern corner. This
was not only an architectonic and organizational act
but also one which had to do with considerations of
urban design, for the wonderful result was that the
concert house now has an entrance court – and the
city has gained a square. »A stroke of luck for the mu-
sic palace«, says Tusquets, which »was actually born
to be a freestanding building but always had to deny
this.« Finally the palace now has two entrances of
equal rank: the new, additionally invented one and the
old one which was recently rounded off by two very
large revolving doors jutting halfway out with copper
roofs. From now on, everybody is free to choose as
the main entrance the one which he likes best or
which is nearest to him.

Tusquets displayed the brave imagination absolutely
necessary for the operation's success. He began by
turning his attention to the Neo-Classical church Sant
Francesc. Designed by the architect E.P. Cendoya but
never entirely completed, it had been built side-by-side
to the Palau de la Música. He shortened the strangely

proportioned building by roughly one third (to three
bays), built it up a little bit and finally provided it with
an appropriate termination in the form of a new apse.
In the interior, a mirrored wall recalls the old length. At
the site where the church's presbytery stood, however,
he opened the courtyard for a new entrance – and
thereby opened up the view to the concert house's
western façade, which Domènech built to resemble
the eastern street façade – albeit without any hope
that it would ever be seen.

The small square which has resulted from this is of
course now bordered not only by the apse but also by
one of the new wings which has been added to the
Palau. This wing ends in a tower which is a new identi-
fying mark for the Palau. It presents itself – and is al-
most impossible to overlook – to the narrow alley,
Ramon Mas, when one is coming from the Via Laie-
tana. Here, at the odd, X-shaped enlargement of the
street, one can discern with what brute force the Via
Laietana was once carved into the medieval urban
fabric. Tusquets' corner tower is certainly not an arbi-

und als eine an die Chorvereinigung. Dem Seitenflügeleingang gegenüber, auf einem der Apsis vorgefügten runden Pfeilerpodest, dirigiert nun auch, in Bronze gegossen, Lluís Millet, der Gründer des Orfeó Català.

Durch den Anbau war es möglich geworden, das Erdgeschoß des Palau von allen Nebenräumen, die da hineingepfercht waren, zu befreien und ihm eine erholsame Großzügigkeit zu geben. Den Gewinn hat der neue Eingang – und hat das Café, dem jetzt der ganze Raum unter dem Parkett des Saales zur Verfügung steht; mit seinem dem Stil des Hauses anempfundenen Interieur rings um eine quadratische Theke in der Mitte entfaltet es eine angenehme Atmosphäre. Am meisten profitiert das Haus aber von einer einläufigen, weit hinauf reichenden Treppe. Sie nimmt genau den Spalt ein, der das Konzerthaus von der Kirche nebenan trennt. Ihr Kennzeichen: spielerische Transparenz. Die Spiegelungen an der Außenseite: gewollt.

Tusquets hatte eine schöne Eingebung. Er setzte vor Domènechs Fassade, die er den Blicken zugänglich gemacht hat, eine ausdrücklich von keinerlei Sprossen geteilte Glaswand. Sie wirkt wie ein Schleier, der auf das Geheimnis der alten Architektur und ihres Interieurs deutet. Sie reicht bis zu einem Gesims unter der obersten Fensterreihe hinauf, eine homogene, die Umgebung maßvoll spiegelnde, die alte Fassade ehrerbietig zu erkennen gebende transparente Fläche. Sie erstreckt sich seitlich so weit, wie die Kirche es erlaubt. Doch in Wirklichkeit führte Tusquets sie im Inneren weiter, so weit wie die lange Treppe reicht. Wer die Stufen hinauf- oder hinabschreitet, sieht auf der »Innenseite« zum Greifen nahe die Außenfassade des Palau de la Música, auf der »Außenseite« hingegen die Kirchenwand, genauer: mehr das Spiegelbild von Domènechs Architektur. Ein wunderbarer Einfall! Er macht das Treppensteigen zum visuellen Vergnügen – und steht darin Domènechs Treppenkunst kein bißchen nach. Natürlich hat der ästhetische Effekt auch einen praktischen Zug. Denn dank dieser zusätzlichen Treppe füllt und leert sich das Haus schneller als je.

Oscar Tusquets, der mit seinem architektonischen Werk sonst eher an jemanden wie Hans Hollein und dessen unbändige Designlust denken läßt als an die gezügelte, der klassischen Moderne näherstehende Baukunst Carlo Scarpas, hat sich auch bei der Gestaltung des Inneren eine sympathische Zurückhaltung auferlegt. Manchmal erinnert sie sogar an Alvar Aalto. Tusquets hat schöne, schwingende Räume entworfen; Treppengeländer, Beleuchtungskörper, Fußböden und Wände sind angenehm einfach gestaltet, das Dekor hält sich zurück, die Farben tun desgleichen. Und dennoch ist überall die Persönlichkeit des Architekten auszumachen. Das liegt keineswegs nur an einigen – und gottlob nicht unterdrückten – kessen Einfällen, etwa für den originellen Lichthof im Anbau, für die Toilettentische oder die Bar im alten Eingangsbau. Mit der Postmoderne hat dies beinahe nichts zu tun, eher etwas mit der betagten, aber immer noch klaren, erfrischenden Moderne, deren Fortsetzung Tusquets hier auf eigenwillige Weise gelungen ist.

Manche wird das verwundern; denn tatsächlich liebäugelt er als Architekt – fast mehr denn als Designer – mit dem historistischen Wink der Postmoderne. Man nannte ihn traditionell und kommerziell. Am ehesten trifft auf ihn wohl die Bemerkung zu, er sei, besonders als Designer, »avantgardistisch und gleichzeitig konservativ«. Keine schlechte Neigung, wie seine Haltung

beim Um- und Anbau und bei der vorsichtig erneuernden Restaurierung des Palau de la Música Catalana, des imposanten Werks seines großen Kollegen Lluís Domènech i Montaner, bewiesen hat. Der 1941 in Barcelona Geborene und dort auch Ausgebildete wurde relativ frühzeitig international bemerkt, vom Museum of Modern Art in New York ebenso wie von der IBA, der Internationalen Bau-Ausstellung in Berlin. In einem Gespräch mit der Zeitschrift *Baumeister* (10, 1991) sagte er, alle seine Entwürfe hätten dieselben Wurzeln, und man finde diese in der katalanischen Tradition, in der gesamten Stilgeschichte und in den Naturstudien, die er zeichnend pflege.

Vielleicht ist sein bestes Werk bisher das so sorgfältig und so stilsicher restaurierte und ergänzte Konzerthaus des Orfeó Català, und vielleicht verdankt er es der anstrengenden Konkurrenz mit dem alten Baumeister – und den Zügeln, die er sich dafür angelegt hatte. Seine Arbeit ist kongenial. Ihm glückte die schwierige Symbiose der Gegenwart mit dem historischen Bauwerk. Das Neue zeigt selbstbewußt, daß es von heute ist; dies ist seine Art des Respektes. Jedoch fügt es sich scheinbar nahtlos, in Wirklichkeit klar erkennbar als ein Werk von Tusquets in und an das Alte. Und so fällt es nicht schwer, an die Virtuosen dieses Geschäfts zu denken, an Carlo Scarpa in Venedig und an Karljosef Schattner in Eichstätt.

Hier, beim Entwurf des Palau de la Música Catalana, schrieb Oriol Bohigas, habe Domènech i Montaner »das modernistische Fieber ergriffen«. David Mackay wiederum hatte eine andere Assoziation. Ihm fielen die berühmten Metaphern ein, die den Aggregatzustand der Architektur bezeichnen sollen; der Philosoph Schelling sah darin »erstarrte Musik«, sein Kollege Schopenhauer »gefrorene Musik«. Goethe erzählte Eckermann, ihn habe das Spiel der »vielfachen horizontalen und tausend vertikalen Linien« römischer Gebäude »wie eine stumme Musik« entzückt. Aber was wäre, wenn sich derlei erstarrte Musik löste, wenn gefrorene Musik zu tauen, stumme zu klingen begänne? All diese Versuche, dem Geheimnis einer Wirkung auf die Spur zu kommen, führen in die Irre. Beim Palau de la Música ist es viel einfacher: Er ist Musik – mit seinem Linienspiel, seinem Relief, den wundersamen Farben, der Kraft des Materials, der Proportionierung und, nicht zuletzt, diesem raffinierten Rhythmus. Ein Gebäude, das in den Augen einen Klang erzeugt. Warum nicht den populären Satz nennen: »Da ist Musik drin«?

9. Oscar Tusquets und Lluís Clotet, Haus auf der Insel Pantelleria, Italien. 1972–75.
10. Oscar Tusquets und Lluís Clotet, Restaurant La Balsa, Barcelona, 1978/79.
11. Tusquets, Díaz & Assoc., Cavas Chandon, Sant Cugat Sesgarrigues, Barcelona, 1988–90
12. Tusquets, Díaz & Assoc., Villa Andrea, Barcelona, 1992.

9. Oscar Tusquets and Lluís Clotet, house on the Isle of Pantelleria, Italy. 1972–75.
10. Oscar Tusquets and Lluís Clotet, restaurant La Balsa, Barcelona, 1978/79.
11. Tusquets, Díaz & Assoc., Cavas Chandon, Sant Cugat Sesgarrigues, Barcelona, 1988–90.
12. Tusquets, Díaz & Assoc., Villa Andrea, Barcelona, 1992.

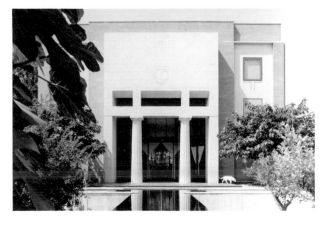

trary invention, but rather a witty homage to the round bay which marks the corner house at the front, on the main street. Even the mushroom-shaped base with the ribbed wreath which has been carved out of stone can be understood as a greeting – sent from afar – to Domènech's columnar mushrooms. In the same way, the transparent upper part of the tower, constructed out of steel and glass, and the distinguished articulation of the brick façades also allude to the old building. The relief in the entrance to the new wing containing the administration, library, archive and conference and rehearsal rooms is also a Jugendstil paraphrase, and is of course dedicated to the Orfeó Català. This can also be read underneath the depiction of the two maidens sitting in the grass and the singing faces of the four women and four men. Without a doubt, each addition is to be understood as a homage to Domènech i Montaner. And there is also a homage to the choral association. Across from the entrance to the side wing, on the base of one of the buttresses in front of the apse, the bronze figure of Lluís Millet, the founder of the Orfeó Català, now stands and conducts.

The extension to the old building allowed for the removal of the auxiliary rooms which had been crammed into the ground storey of the Palau, and for the creation of a peaceful spaciousness on this storey. This has been to the benefit of the new entrance – and of the café. The latter now has all of the space under the stalls at its disposal, and with a square bar at its centre, its interior simulates the style of the house and emanates a pleasant atmosphere. The house profits the most, however, from a staircase which extends far up into the building. It takes up exactly that space which separates the concert house from the church beside it. Its distinguishing mark is a kind of playful transparency. The reflections on the outside are deliberate.

After he had opened it to view, Tusquets had a beautiful inspiration for Domènech's façade: he placed a glass wall in front of it. Deliberately devoid of any mullions, the veil-like wall hints at the secrets of the old architecture and its interior. Extending up to a ledge below the top row of windows, the glass wall is a homogeneous, transparent expanse which gently reflects its environment and respectfully reveals the old façade. At the side of the building, this expanse reaches as far as the church will allow. In reality, however, Tusquets continues with the wall in the interior, taking it as far as the long staircase reaches. Whoever walks up or down this staircase will see the outer façade of the Palau de la Música, close enough to touch, on the »inner side«, and the church wall or more precisely, the mirror image of Domènech's architecture on the »outer side«. It is a wonderful idea! It makes climbing stairs into a visual pleasure – and is comparable to Domènech's artistry with stairs. Of course the aesthetic effect also has a practical side, for thanks to this additional staircase the house can now be filled and emptied more quickly than ever before.

Oscar Tusquets' architectonic work generally tends to remind one more of Hans Hollein and his untrammeled passion for design rather than the restrained architecture of Carlo Scarpa which is closer to classical Modernism. Nevertheless, Tusquets demonstrated an admirable restraint in his fashioning of the interior. Sometimes it even reminds one of Alvar Aalto. Tusquets designed beautiful, animated rooms. The banis-

ters, lighting elements, floors and walls have been designed with pleasant simplicity, the decor is restrained, and the same is true of the colours. And yet, the personality of the architect can be discerned everywhere. This is certainly not only because of several high-spirited ideas – fortunately not suppressed – such as the novel air well in the extension, the dressing tables or the bar in the old entrance. They have almost nothing to do with Post-Modernism, but rather with an aged but still clear and refreshing Modernism, which Tusquets has here succeeded in continuing in his own original way. Some might be surprised by this, for as an architect – almost more than as a designer – he is in fact attracted to the historicizing appeal of Post-Modernism. One has called him traditional and commercial, but the most appropriate description is probably the observation that he is, especially as a designer, »avant-garde and at the same time conservative«. This is not a bad tendency to have; as demonstrated by his approach to the work – conversion, extension and restoration – which had to be done on the highly impressive building, the Palau de la Música Catalana, designed by his great colleague, Lluís Domènech i Montaner. Tusquets, who was born in Barcelona in 1941 and also received his training there, gained international recognition – from the Museum of Modern Art in New York and from the IBA in Berlin – relatively early in his career. In an interview with the journal *Baumeister* (10, 1991), he said that all of his designs had the same roots and that these were to be found in the Catalan tradition, in the history of style in its entirety and in nature studies, which he also draws.

Perhaps his best work up to now – executed with great care and with a sure stylistic hand – has been the expanded concert house for the Orfeó Català. The success of this work is perhaps also due to his taxing competition with the old master builder and the self-control to which he subjected himself. His work is congenial. He has been successful in effecting the difficult symbiosis between the present age and the historical building. The new components confidently present themselves as such. This is his way of showing respect. At the same time, however, even though it is in reality clearly Tusquets' work, it also appears to merge seamlessly into and onto the old building. That is why virtuosos of this sort of work – Carlo Scarpa in Venice and Karljosef Schattner in Eichstätt – also come to mind.

Oriol Bohigas wrote that in his design for the Palau de la Música Catalana, Domènech i Montaner was »seized by the Modernistic fever«. For his part, David Mackay had a different association. He thought of the famous metaphors for architecture. The philosopher Schelling saw it as »solidified music« and his colleague Schopenhauer as »frozen music«. Goethe revealed to Eckermann that the play of »the manifold horizontal and thousand vertical lines« of Roman buildings had enchanted him »like mute music«. But what would happen if this solidified music began to dissolve, frozen music began to thaw and mute music began to sound? All of these attempts to detect the secret of an effect lead to nothing. With the Palau de la Música it is much easier. It is music, with its play of lines, its relief, its wondrous colours, the strength of the material, the proportioning and, not the least, the subtleties of its rhythm. It is a building which creates a sound in the eyes. There is music in it.

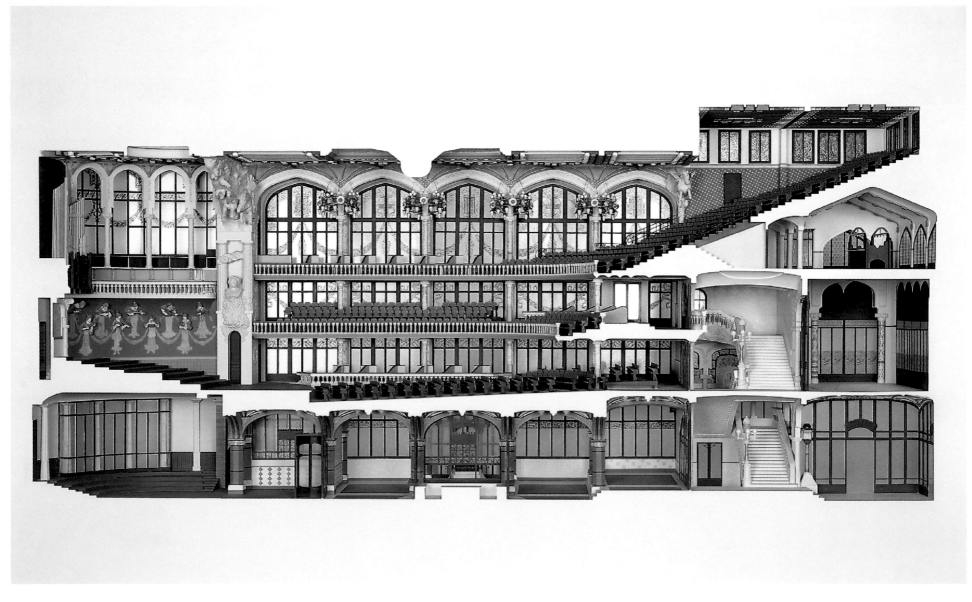

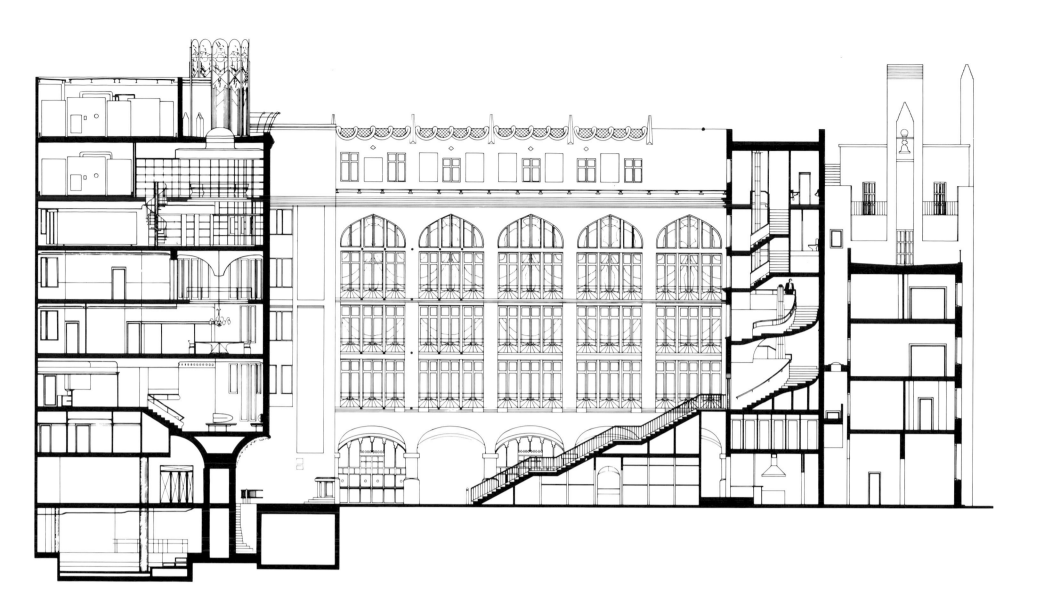

1. Innenraummodell.
2. Längsschnitt.

1. Interior model.
2. Longitudinal section.

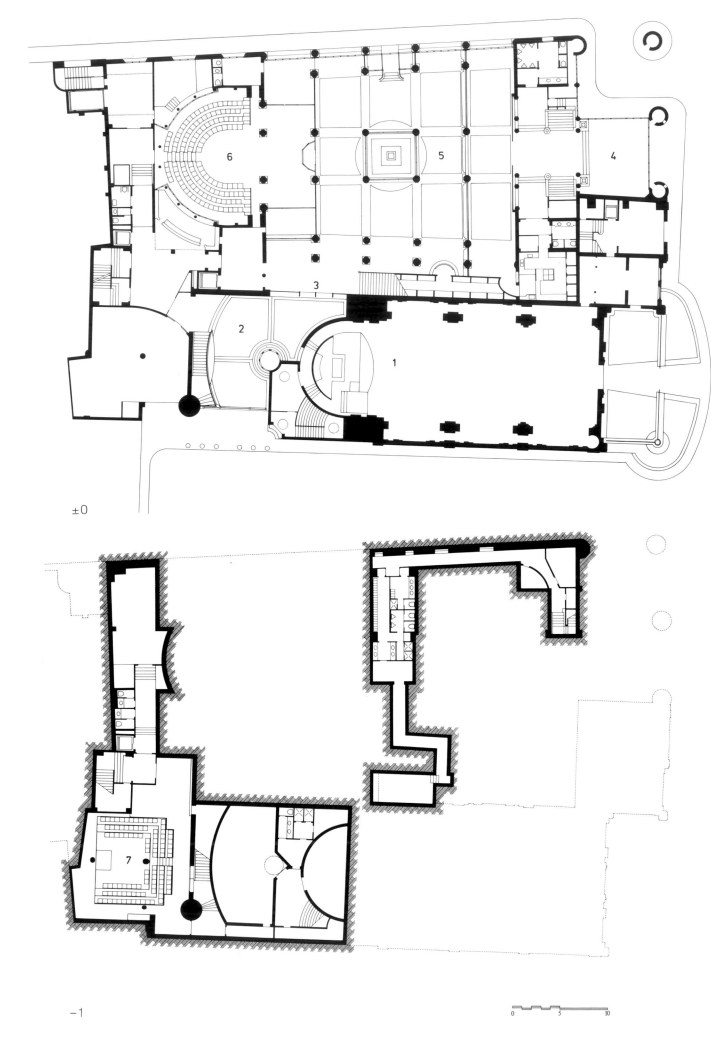

±0

−1

3–6. Grundrisse (Ebenen –1, 0, 1, 2). Legende: 1 Sant Francesc, 2 Platz vor dem neuen Eingang, 3 neuer Eingang, 4 alter Eingang, 5 Hauptfoyer, 6 Kammermusikraum, 7 Probenraum, 8 Konzertsaal, 9 Sala de Lluís Millet, 10 Bar der Musiker.

3–6. Floor plans (levels –1, 0, 1, 2). Key: 1 Sant Francesc, 2 square in front of the new entrance, 3 new entrance, 4 old entrance, 5 main foyer, 6 room for chamber music, 7 rehearsal room, 8 concert hall, 9 Sala de Lluís Millet, 10 bar for musicians.

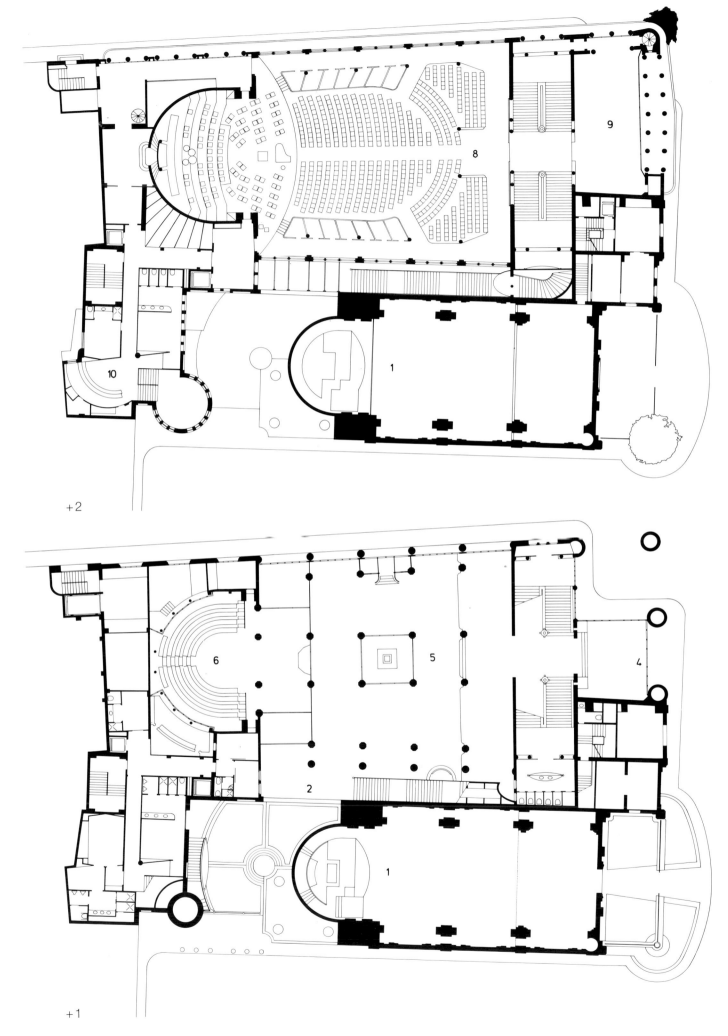

+2

+1

29

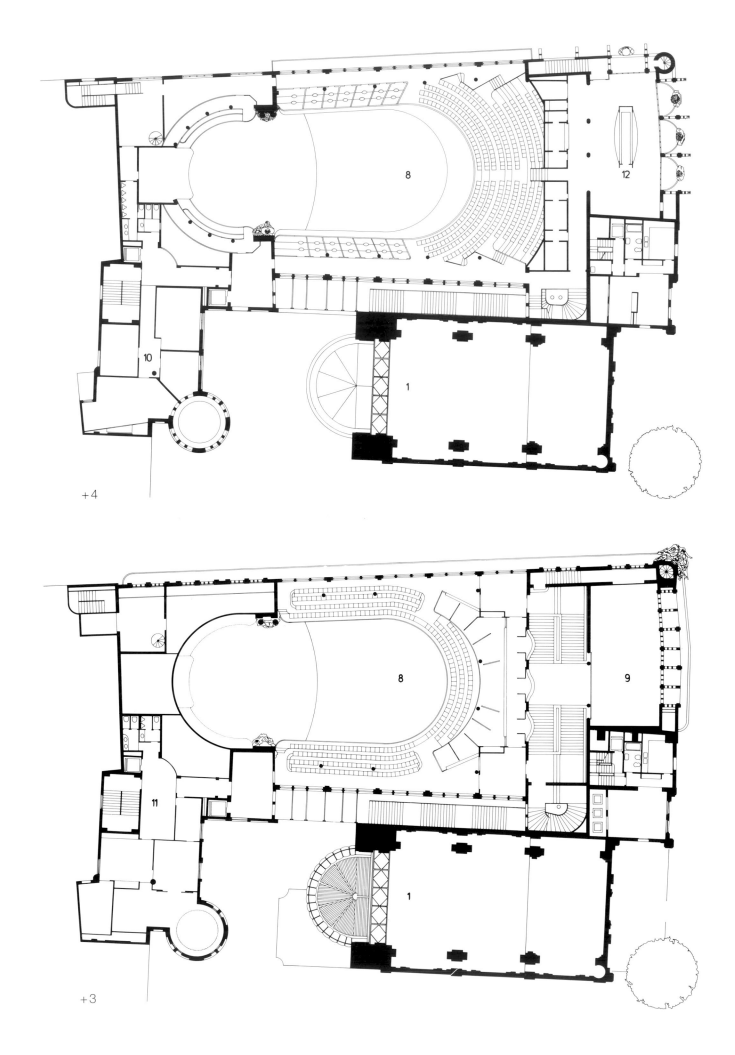

+4

+3

7–10. Grundrisse (Ebenen 3, 4, 5, 6).
Legende: 1 Sant Francesc, 8 Konzert-
saal, 9 Sala de Lluís Millet, 11 Verwaltung,
12 oberes Foyer, 13 Bibliothek.

7–10. Floor plans (levels 3, 4, 5, 6). Key:
1 San Francesc, 8 concert hall, 9 Sala de
Lluís Millet, 11 administration, 12 upper
foyer, 13 library.

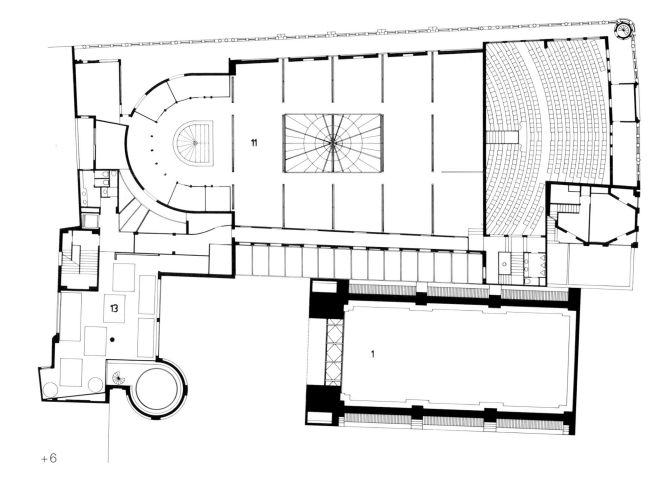

+6

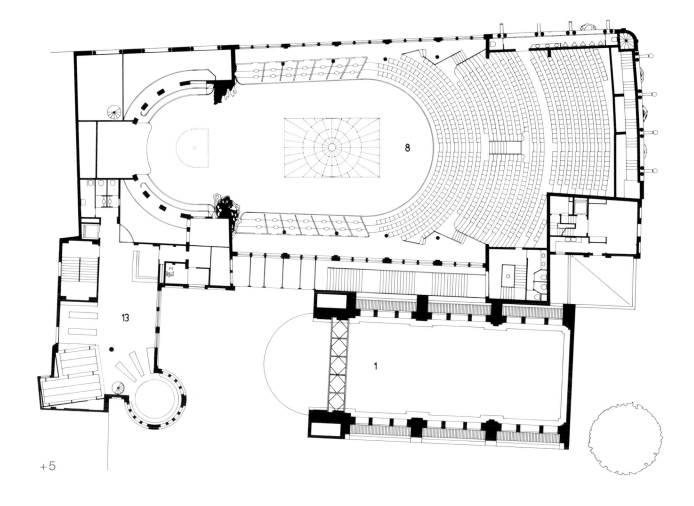

+5

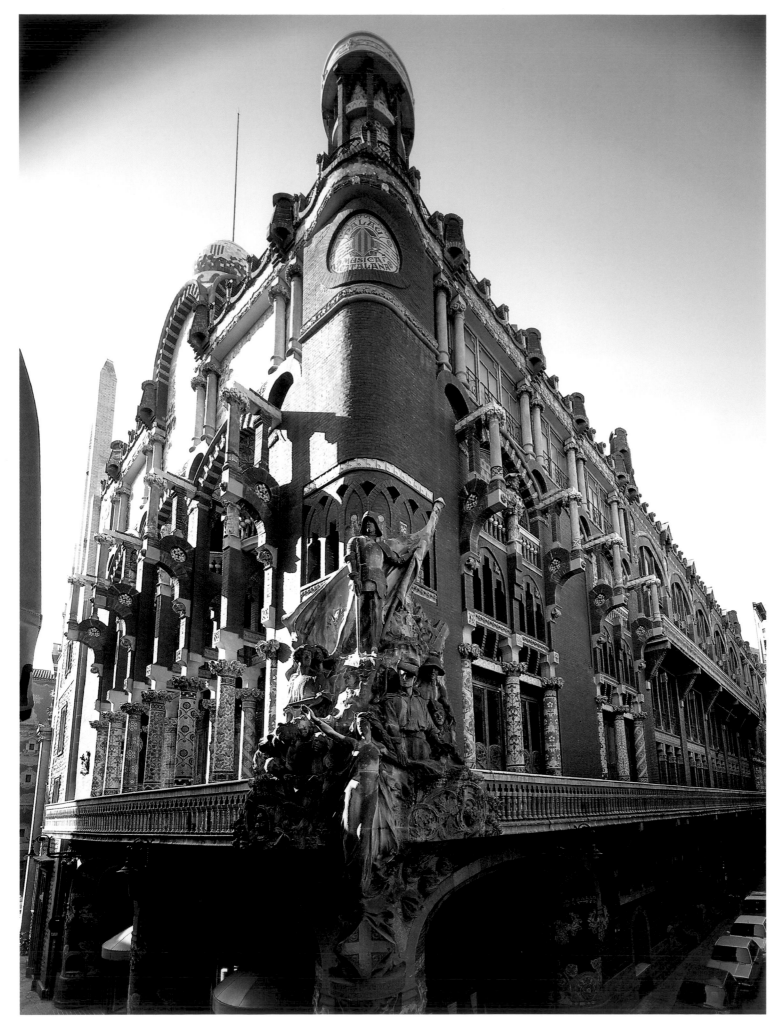

11. Gesamtansicht von Osten.
12. Südostseite mit den alten Eingängen und den neu eingebauten Drehtüren von Oscar Tusquets.

11. General view from the east.
12. South-east side with the old entrances and the newly installed revolving doors by Oscar Tusquets.

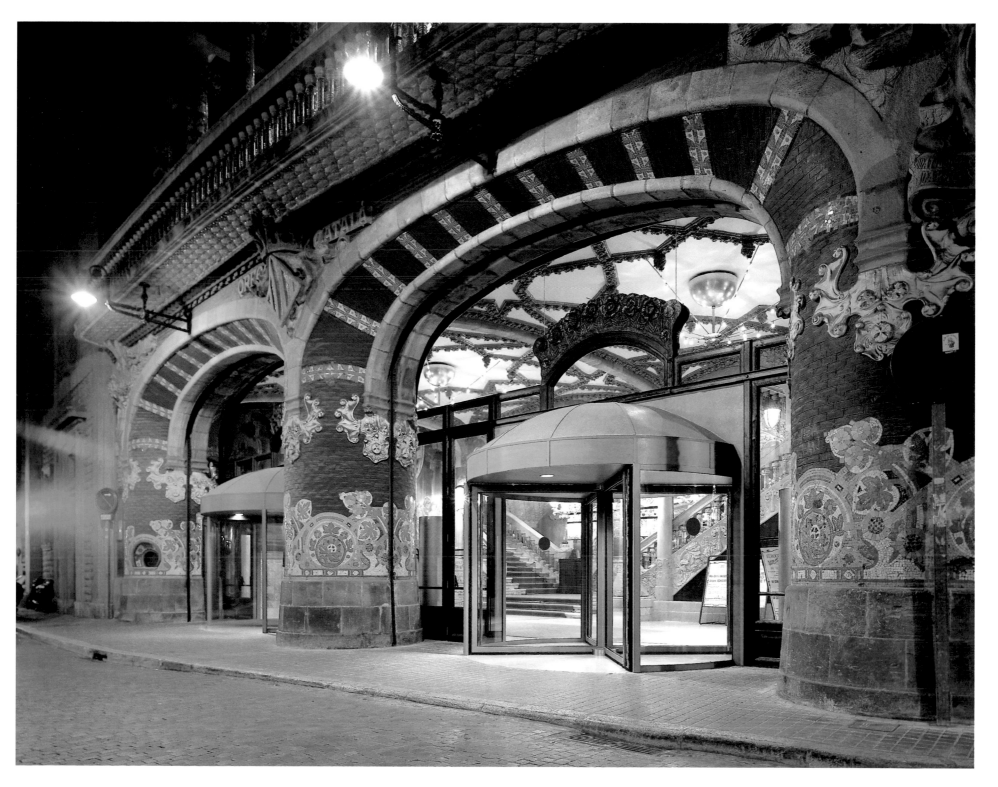

13. Alte Eingangshalle.
14. Altes Haupttreppenhaus

13. Old entrance hall.
14. Old main staircase.

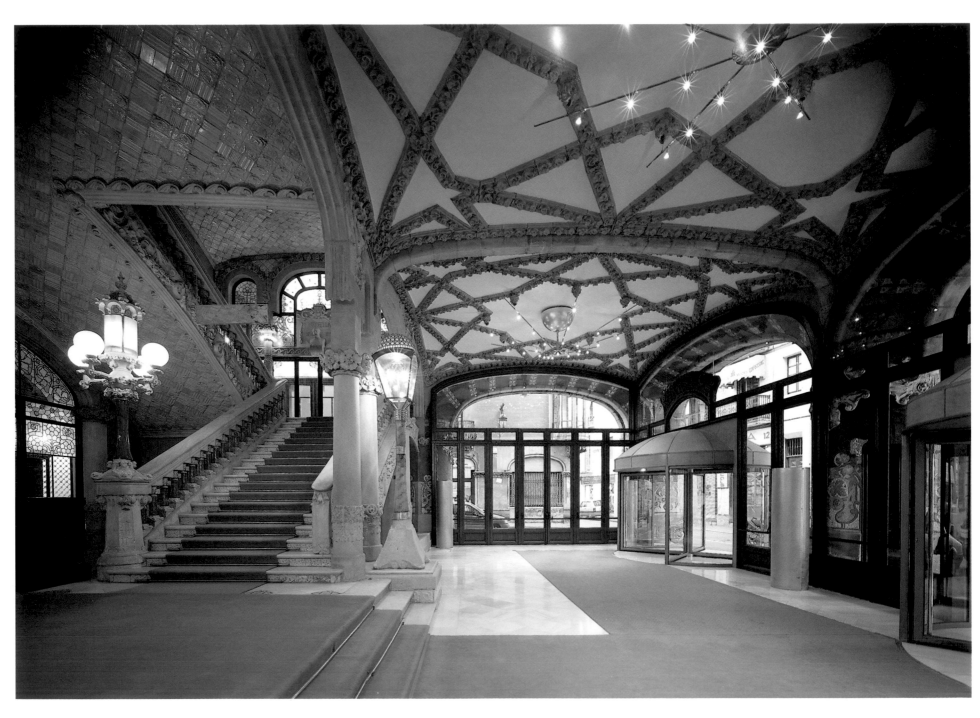

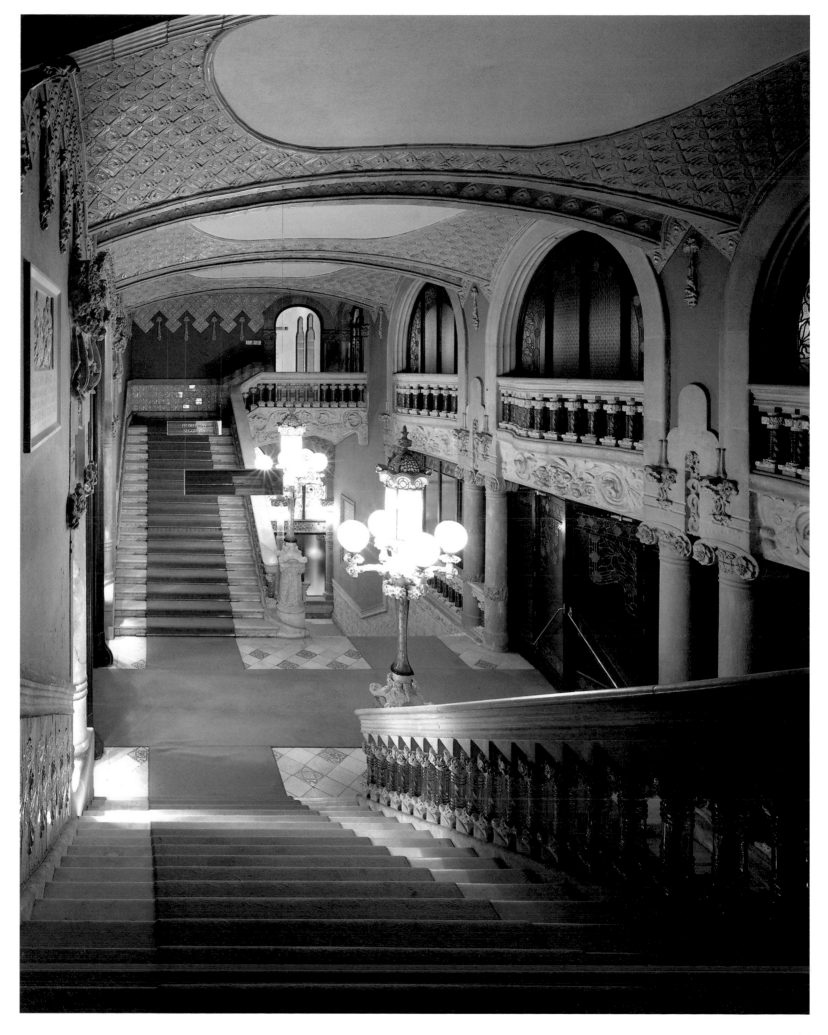

15. Eingang zur Sala de Lluís Millet.
16. Sala de Lluís Millet.

15. Entrance to the Sala de Lluís Millet.
16. Sala de Lluís Millet.

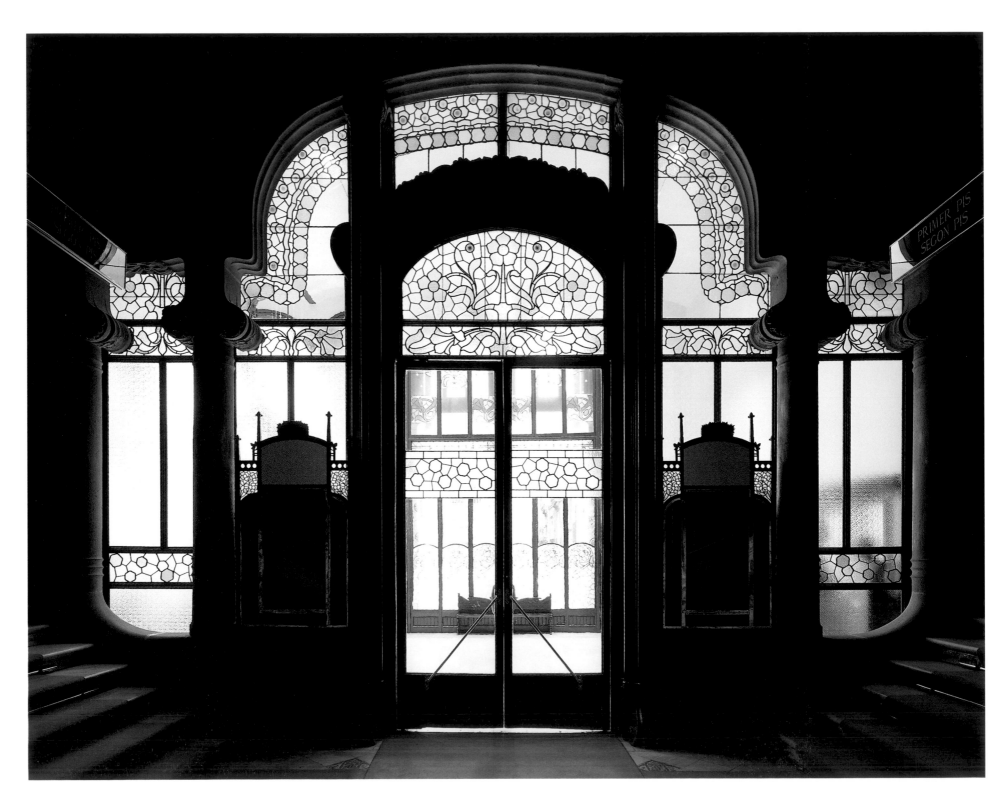

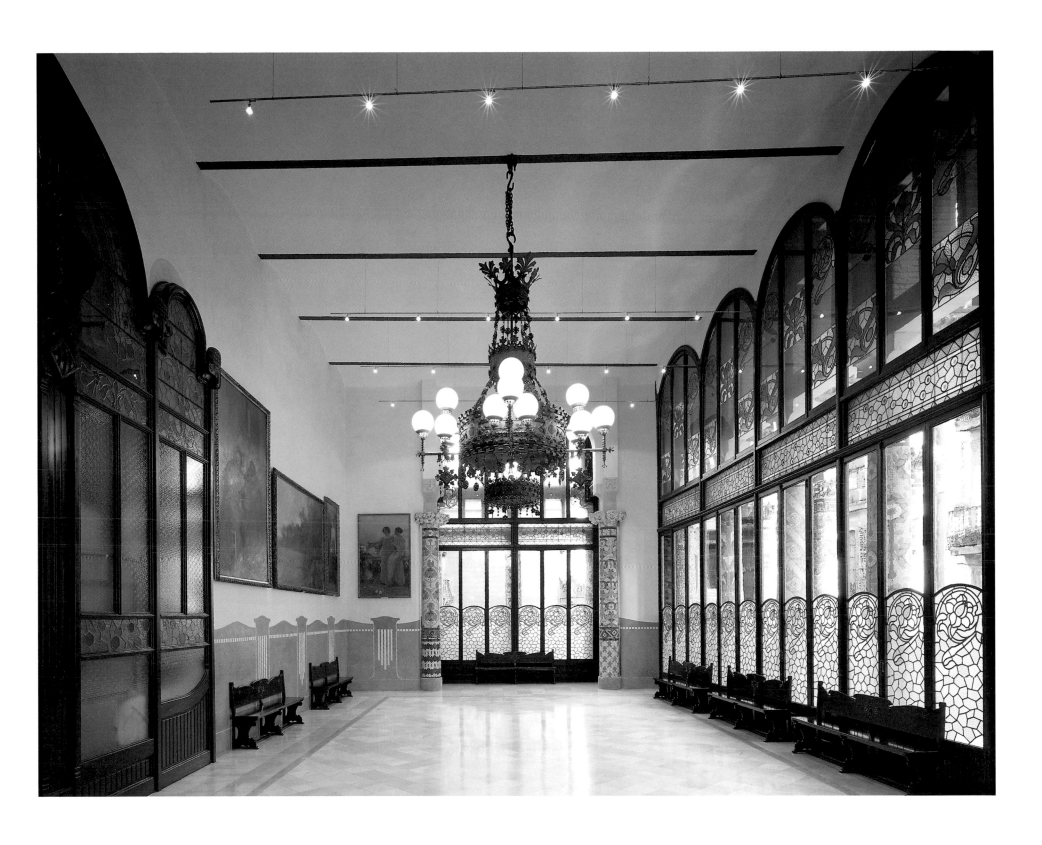

17, 18. Balkon vor der Sala de Lluís Millet.

17, 18. Balcony in front of the Sala de Lluís Millet.

S. 40/41
19. Blick vom Podium in das Auditorium des Konzertsaals.

p. 40/41
19. View from the podium into the auditorium of the concert hall.

S. 42/43
Blick vom zweiten Rang in das Auditorium und auf das Podium des Konzertsaals.

p. 42/43
20. View into the auditorium and of the podium of the concert hall from second circle.

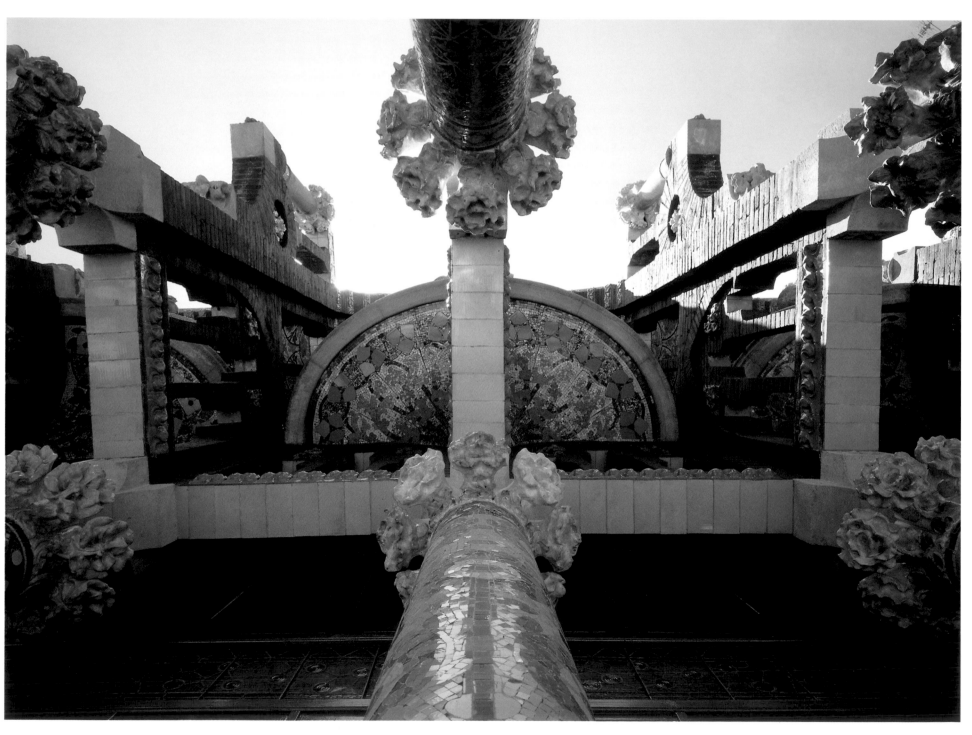

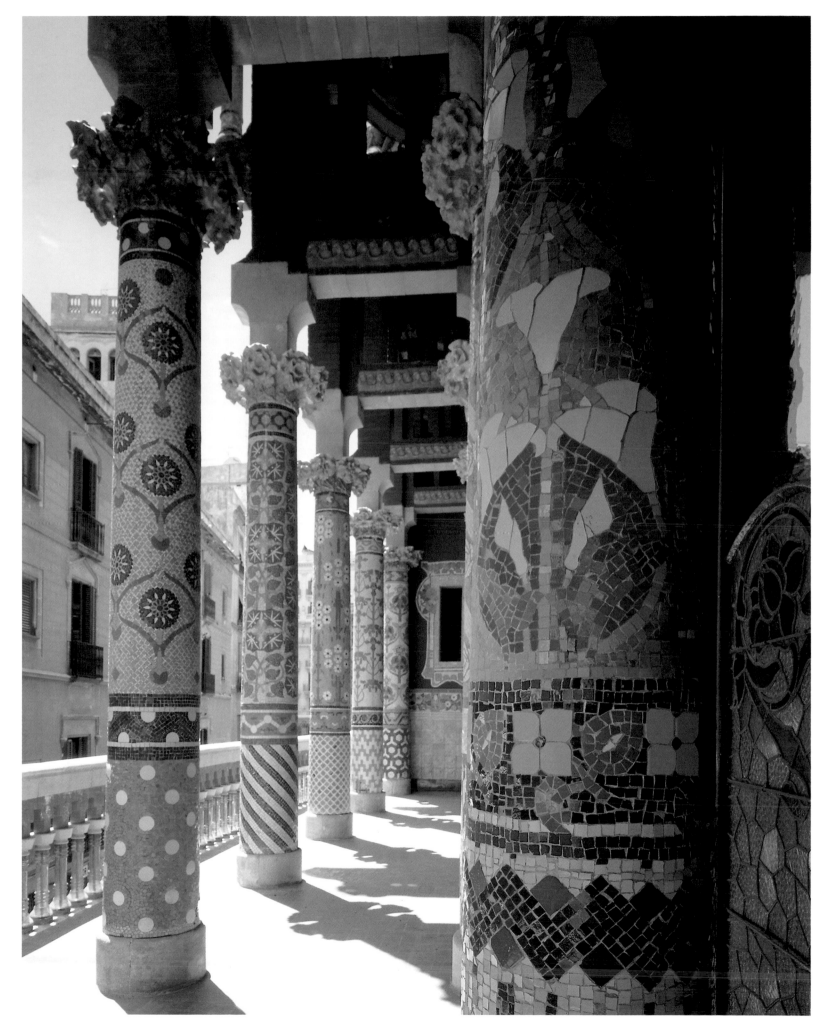

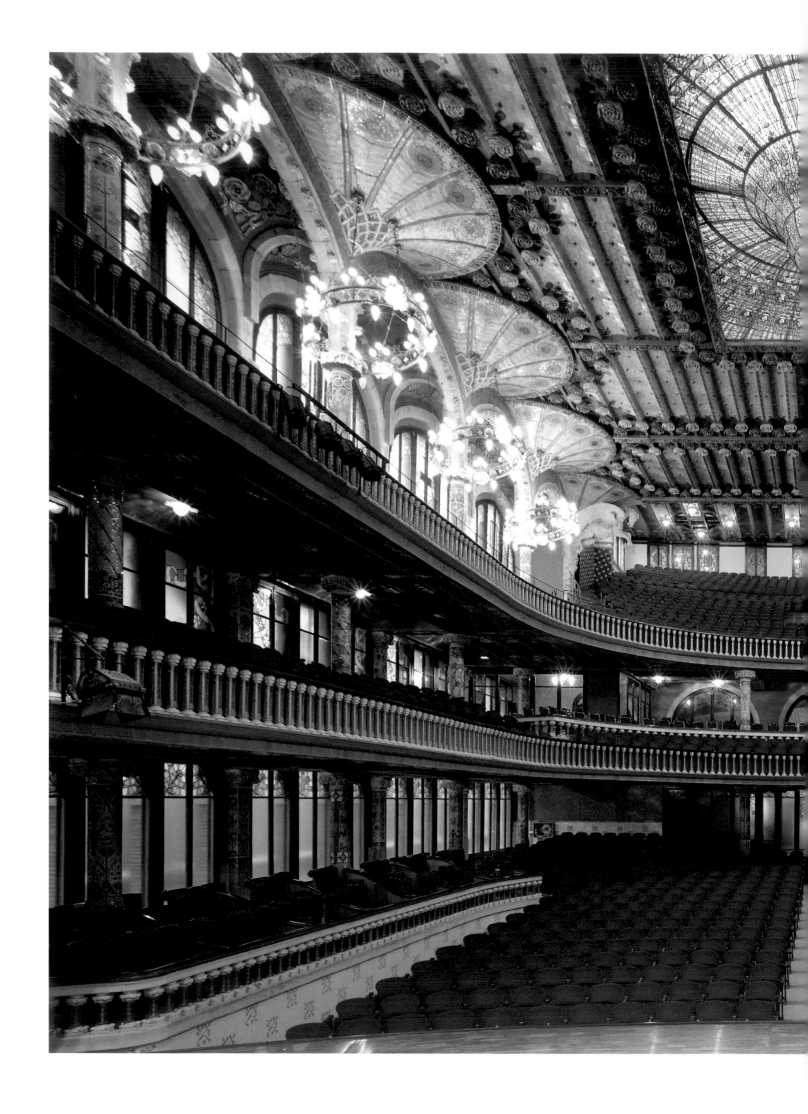

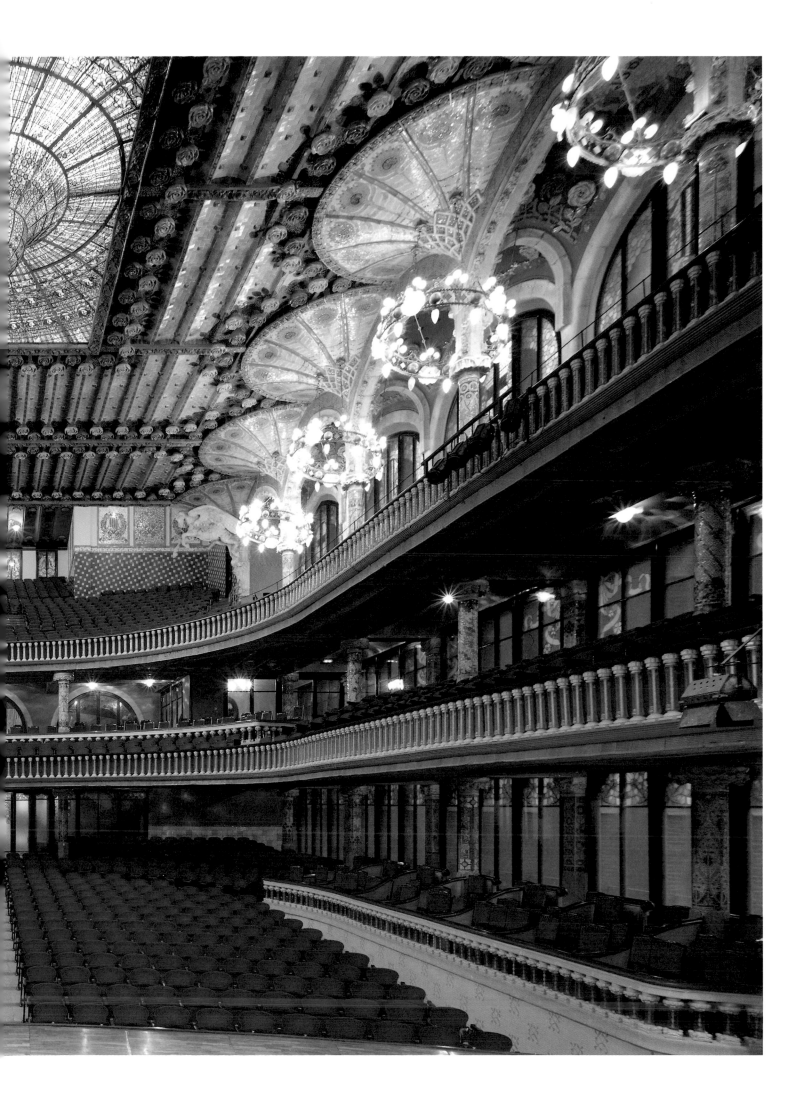

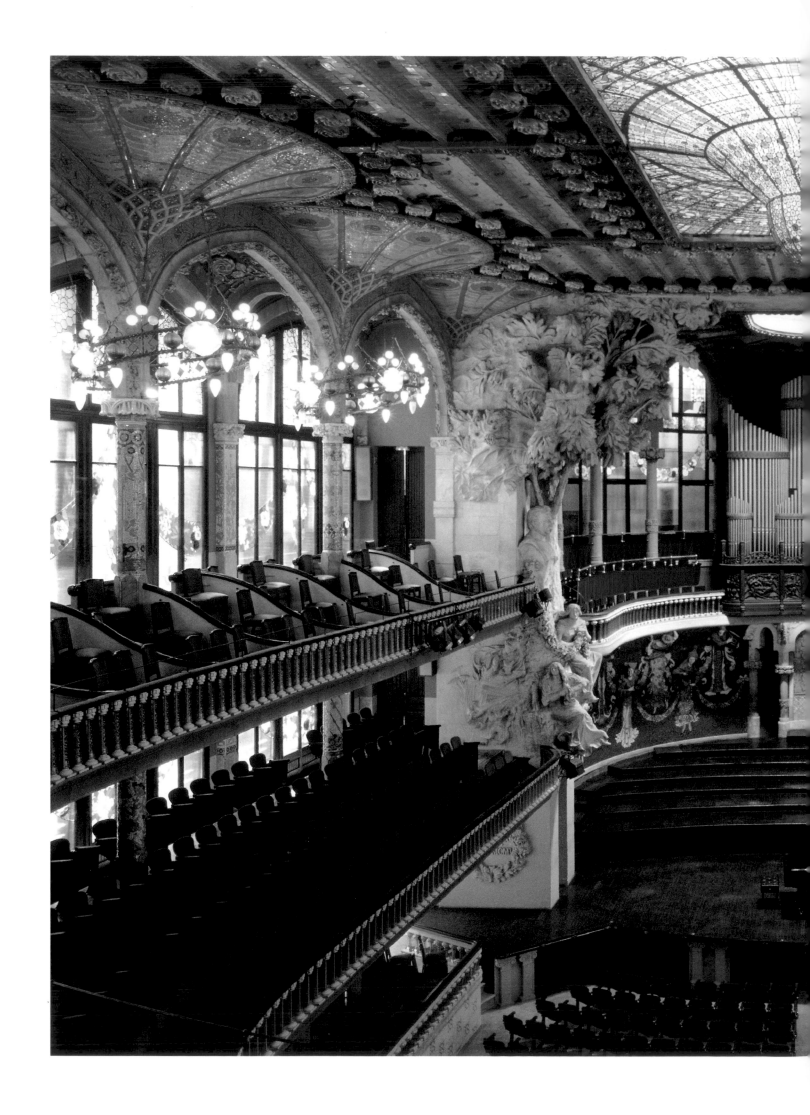

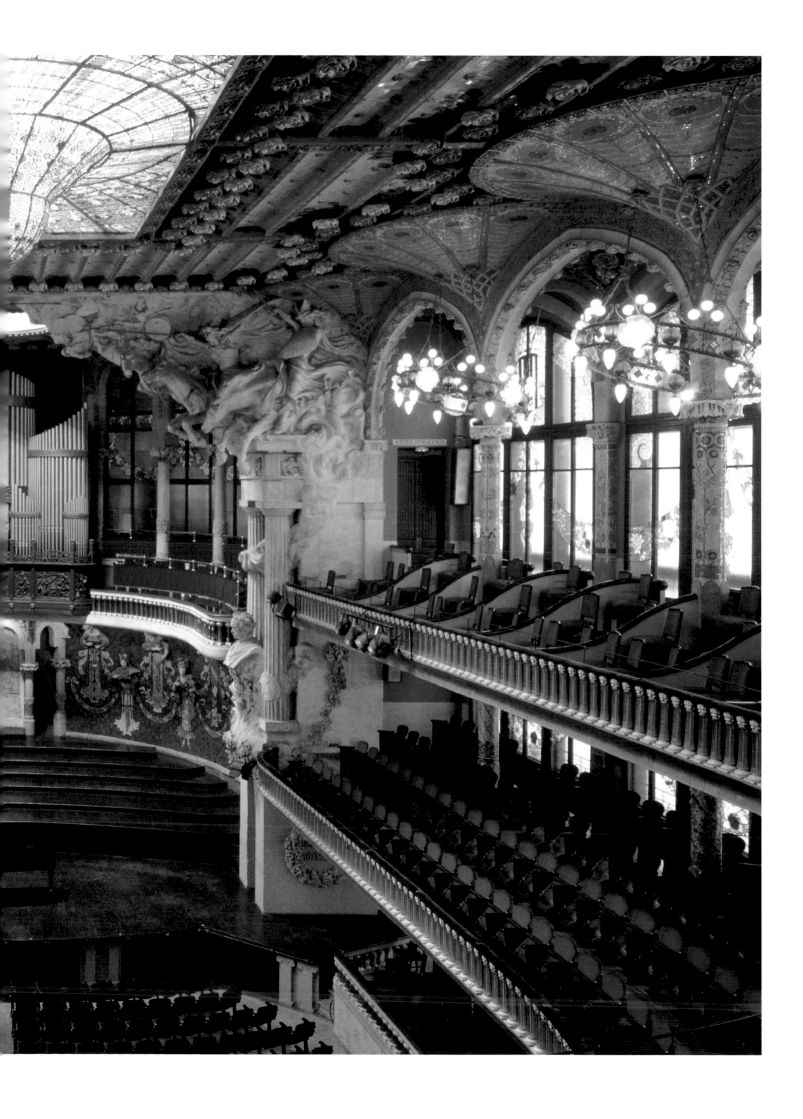

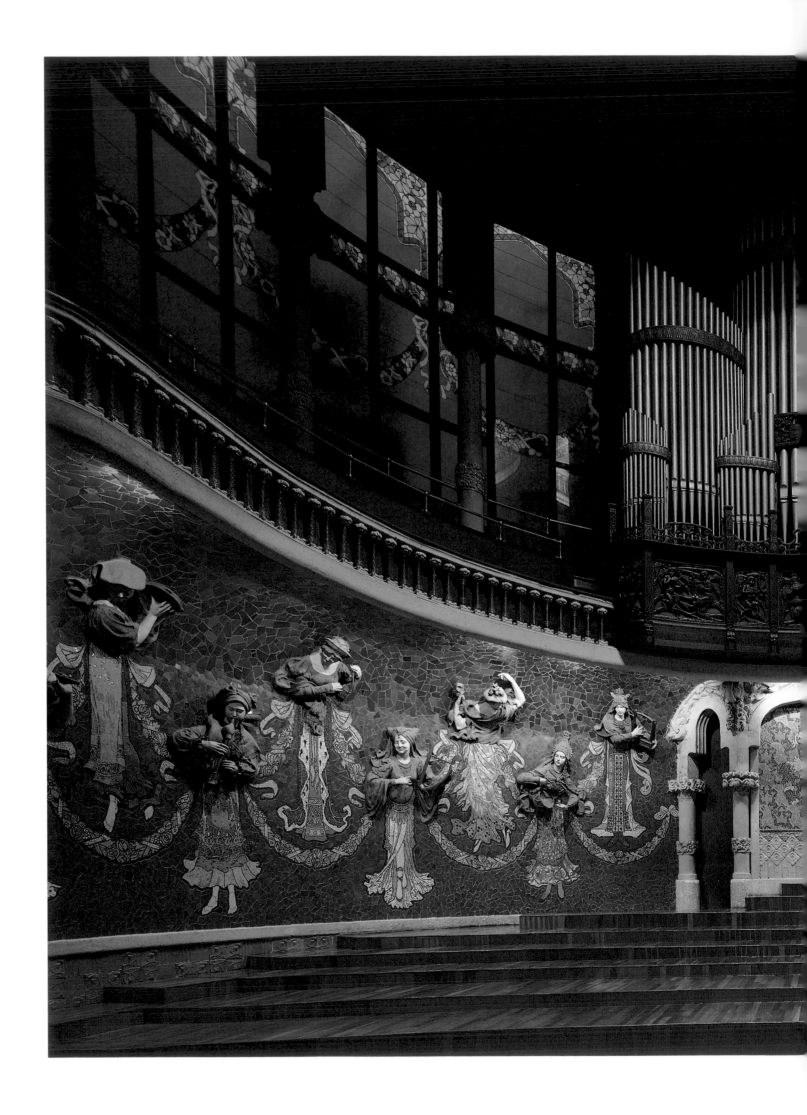

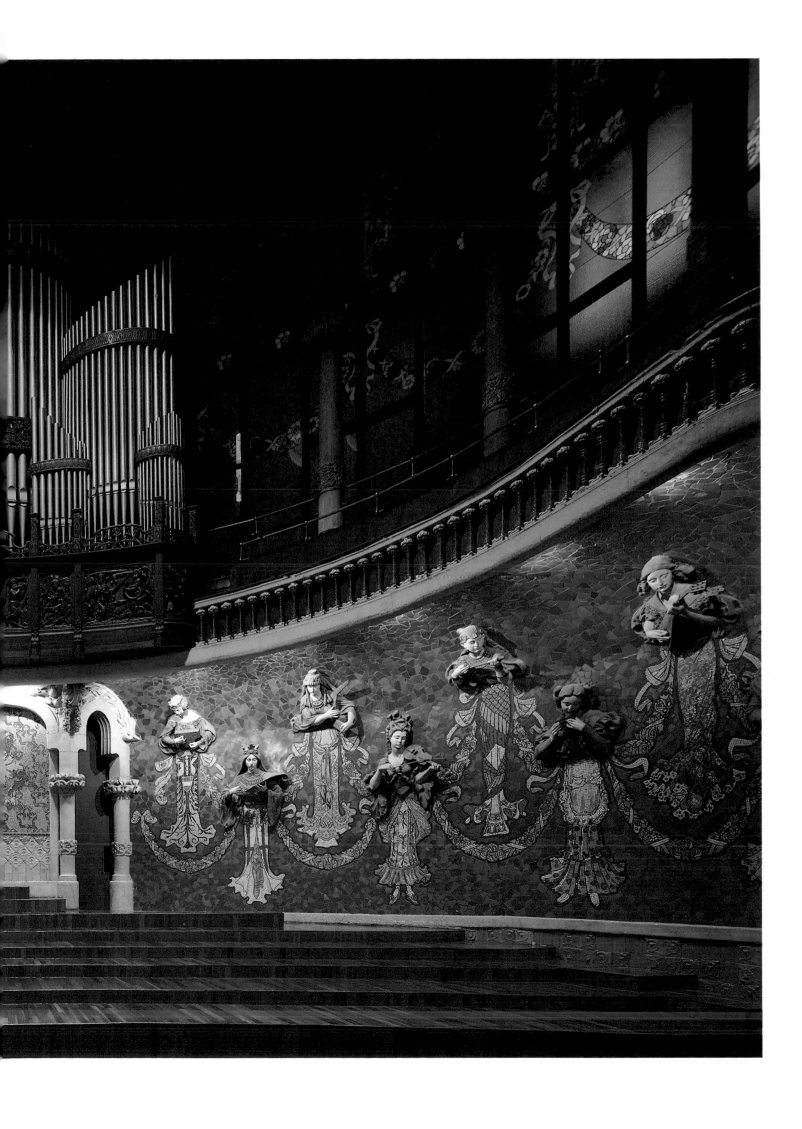

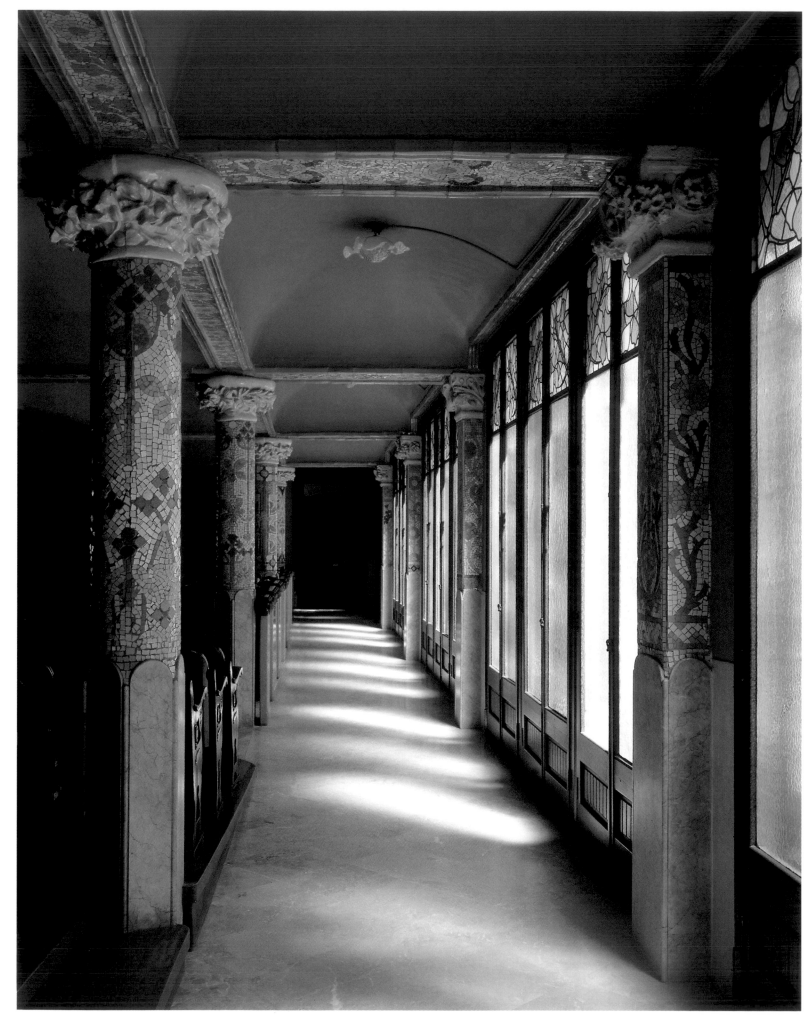

S. 44/45
21. Detail des Podiums und der Orgel des Konzertsaals.

p. 44/45
21. Detail of the podium and the organ of the concert hall.

22. Gang auf der Nordost-
seite des Konzertsaals,
gelegen auf Ebene 2 des
Gebäudes.
23. Blick auf die Nordost-
seite des Konzertsaals.

22. Corridor on the north-
east side of the concert
hall, situated on level 2 of
the building.
23. View of the north-east
side of the concert hall.

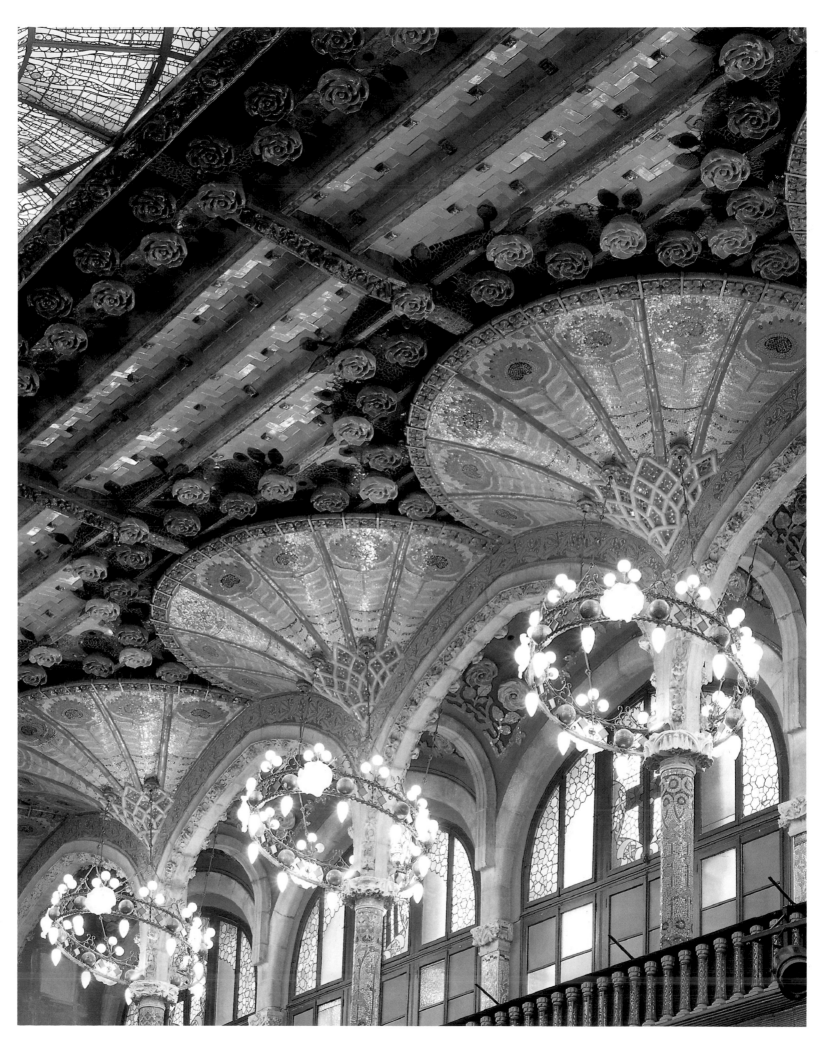

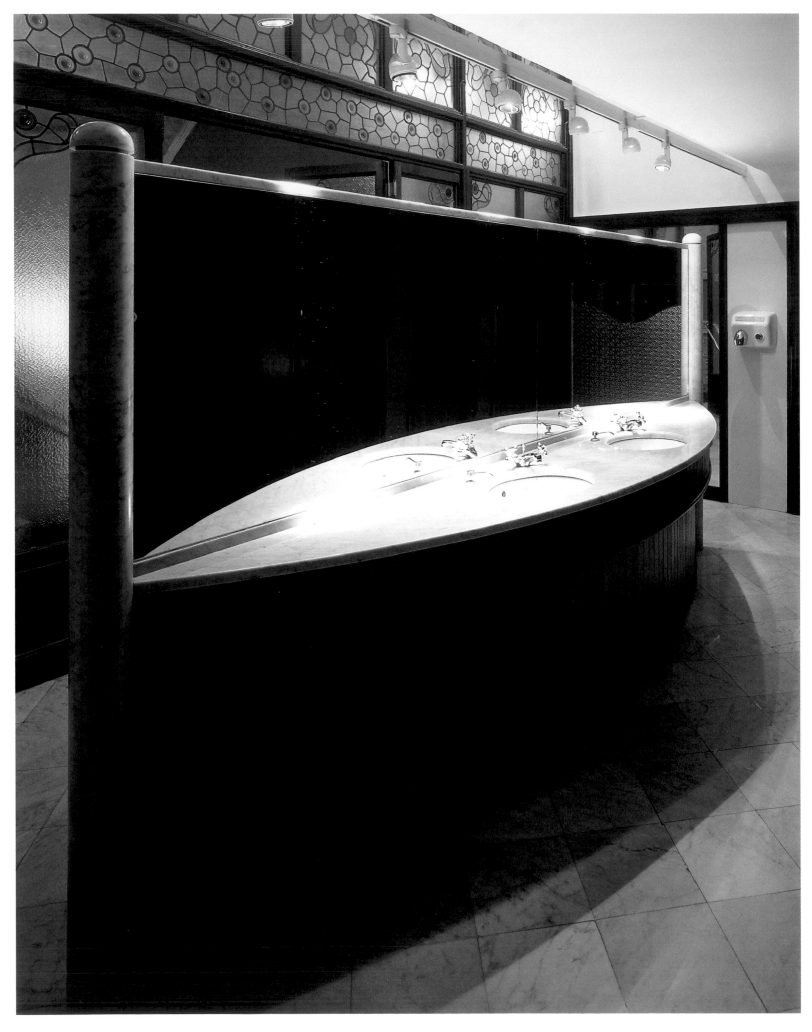

24. Damentoilette auf Ebene 1 am Haupttreppenhaus mit einem Waschtisch von Oscar Tusquets.
25. Oberes Foyer mit einer Bar von Oscar Tusquets.

24. Ladies's room on level 1 next to the main staircase with a wash-stand by Oscar Tusquets.
25. Upper foyer with a bar by Oscar Tusquets.

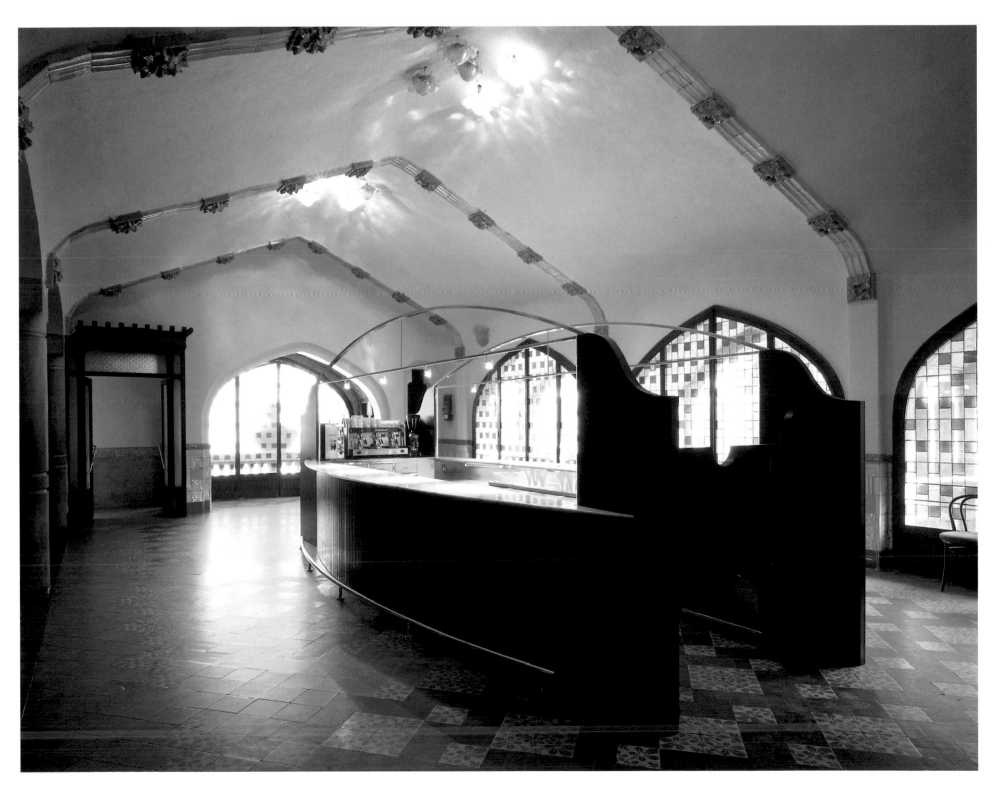

49

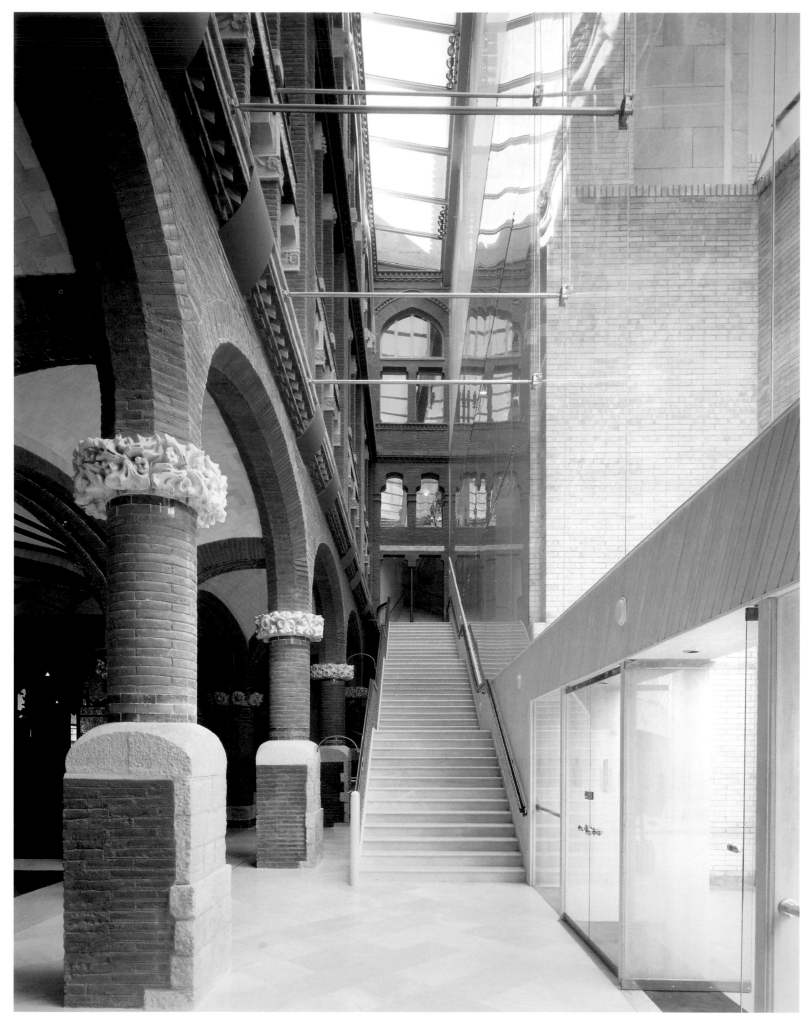

26, 27. Neues Treppen-
haus auf der Südwestseite
des Gebäudes.

26, 27. New staircase on
the south-west side of the
building.

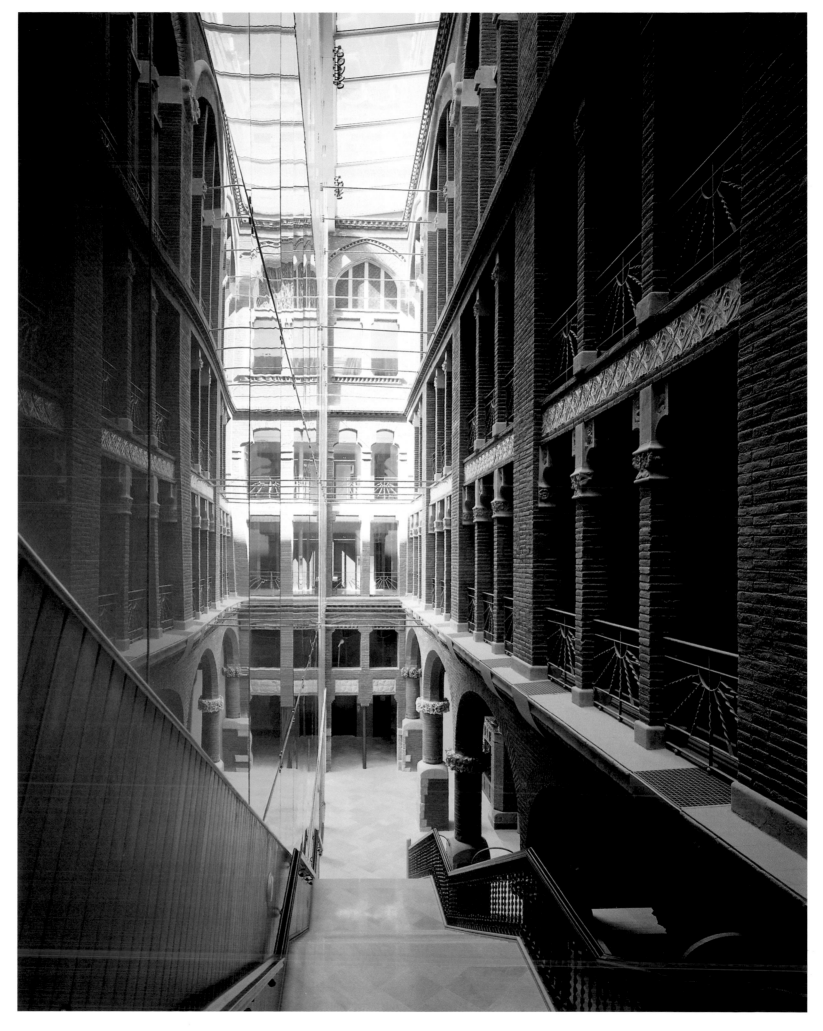

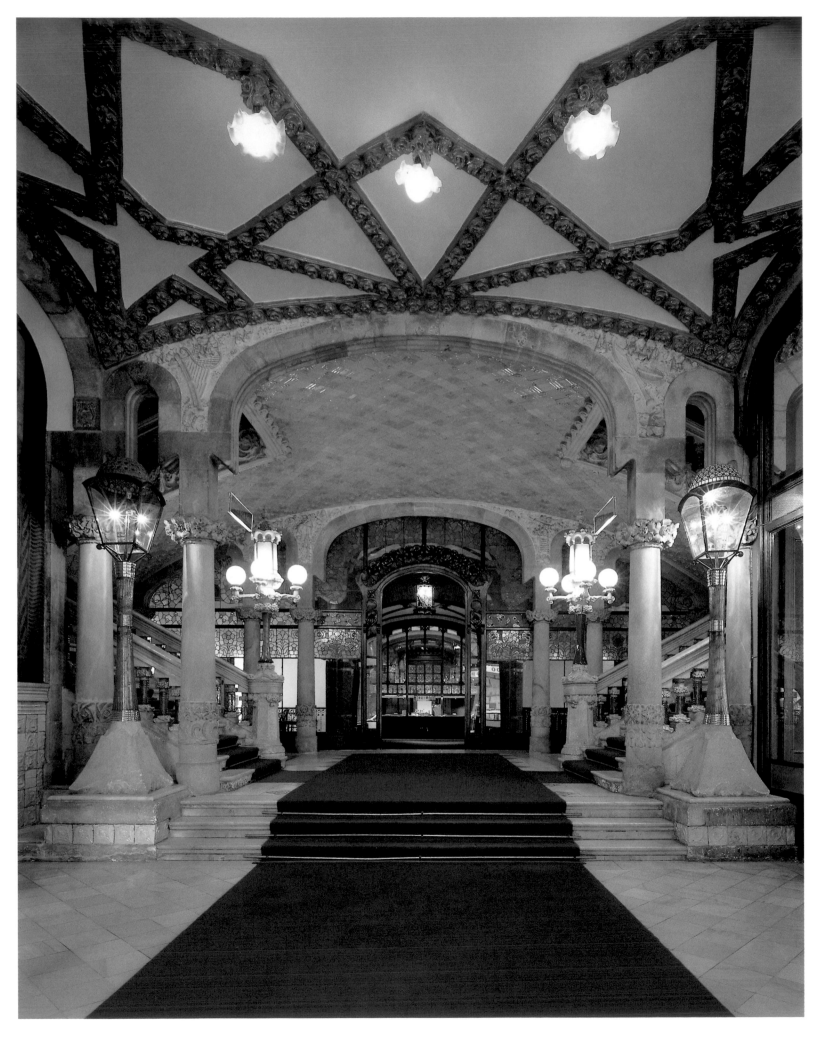

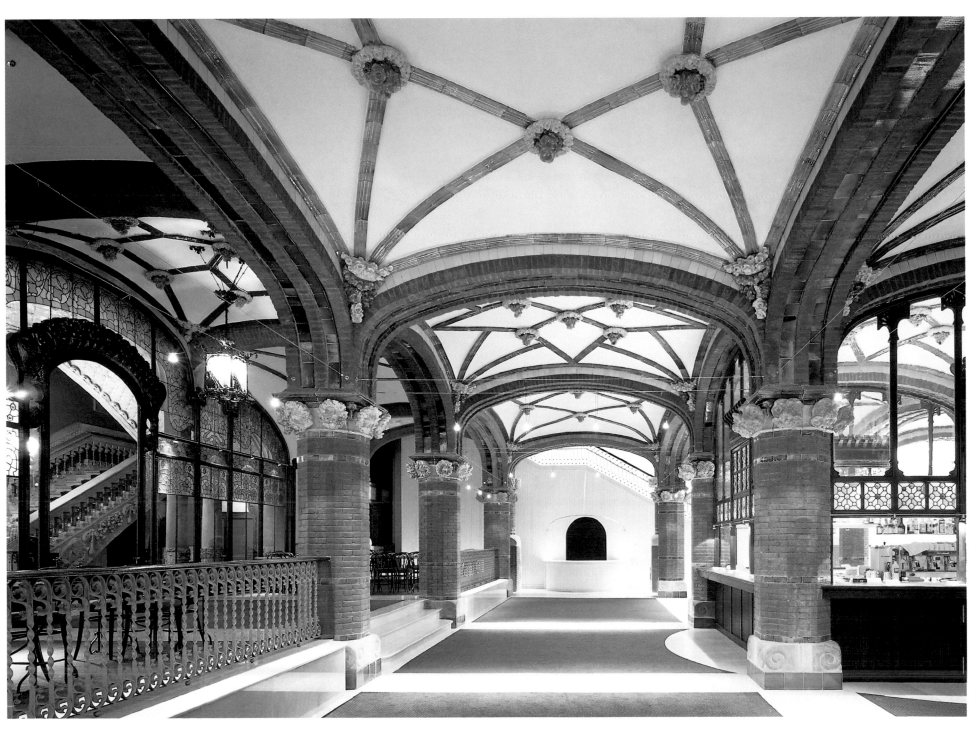

30. Probenraum auf Ebene –1.
31. Kammermusikraum auf Ebene 0.

30. Rehearsal room on level –1.
31. Room for chamber music on level 0.

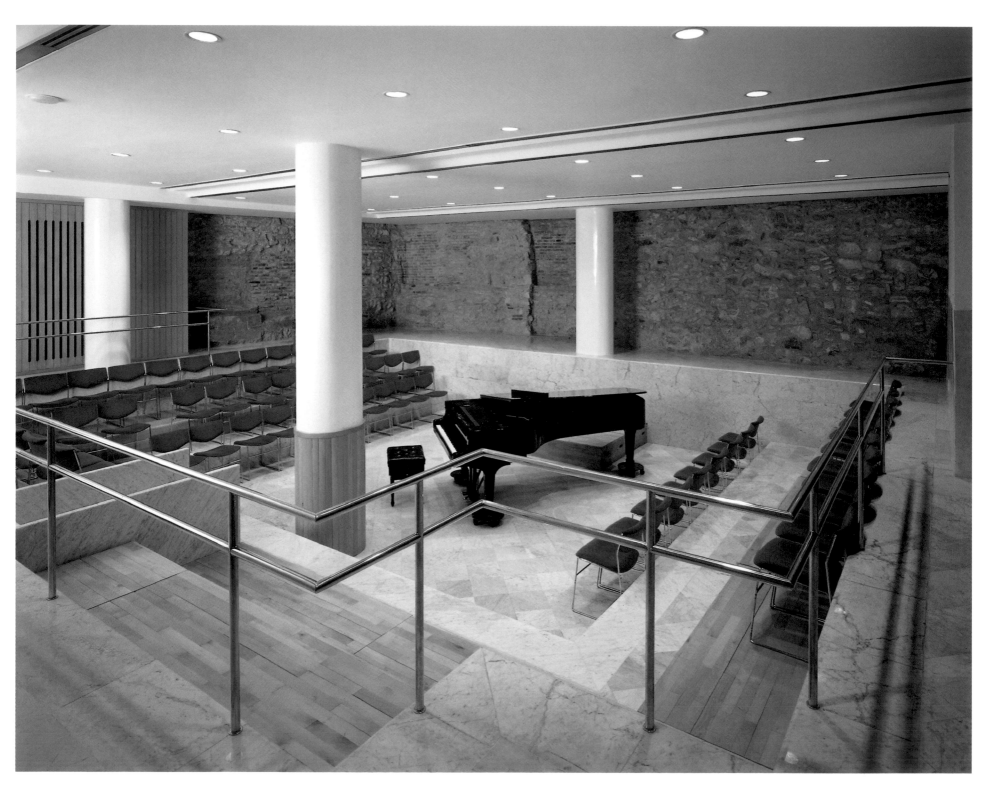

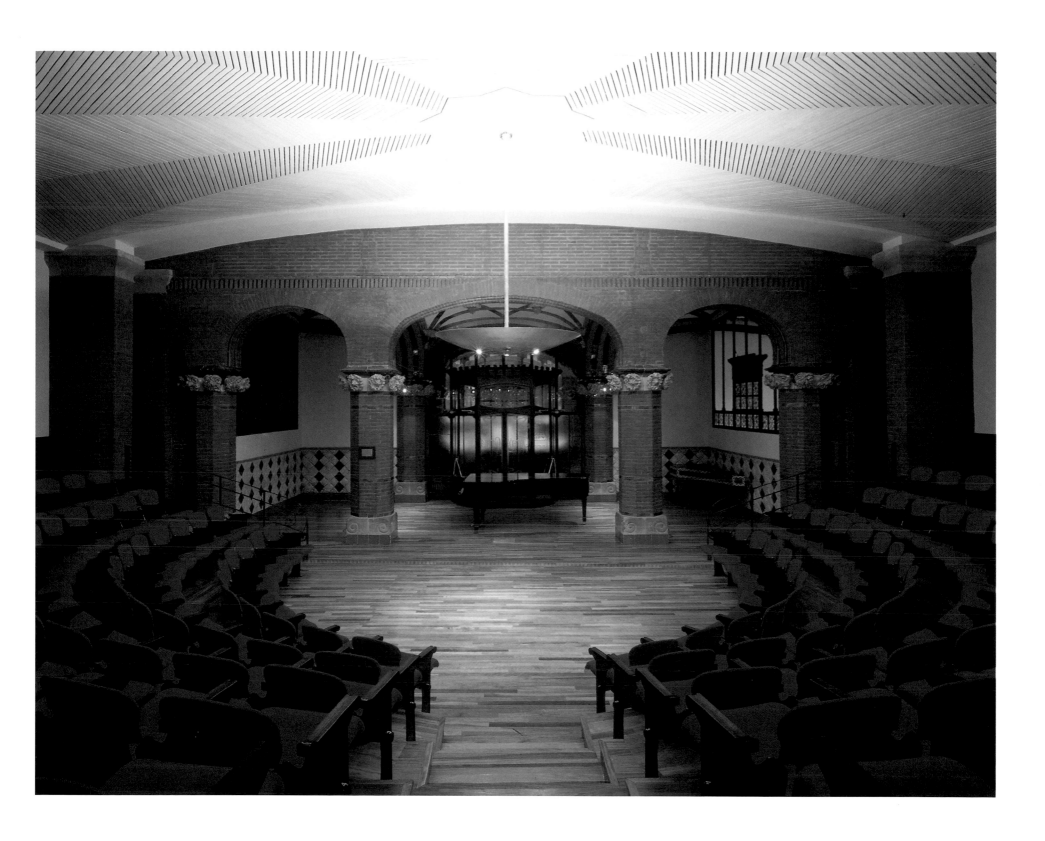

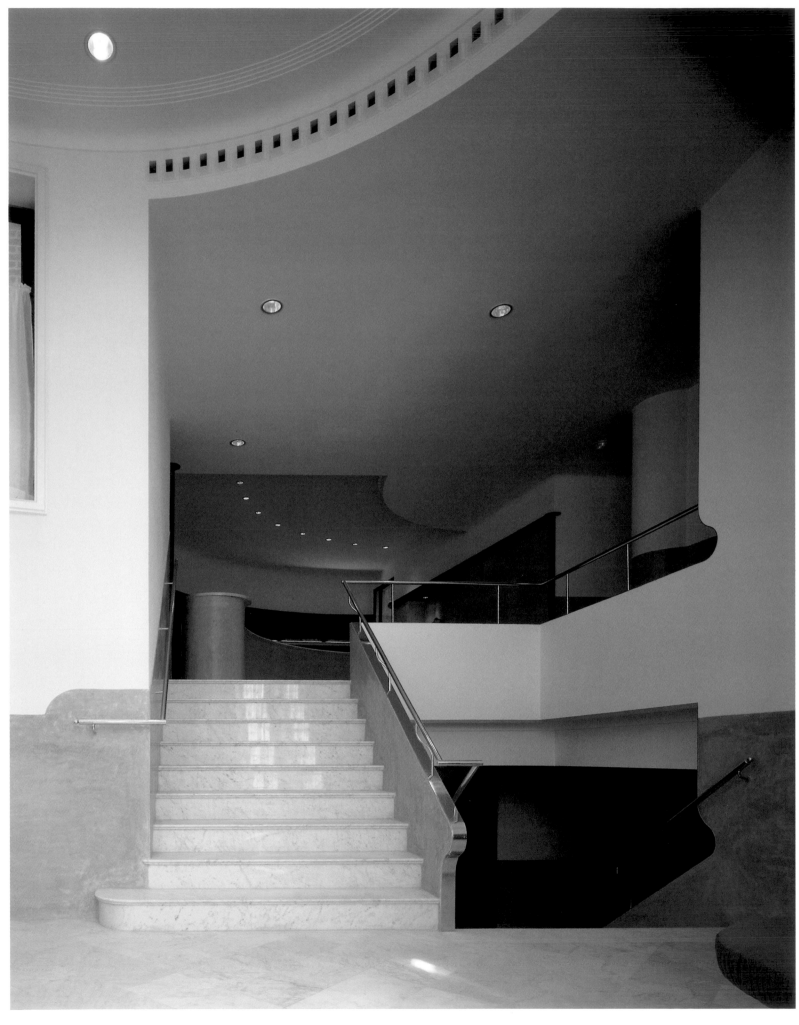

32. Aufgang zur Bar der
Musiker.
33. Bar der Musiker.

32. Stairs to the bar for
musicians.
33. Bar for musicians.

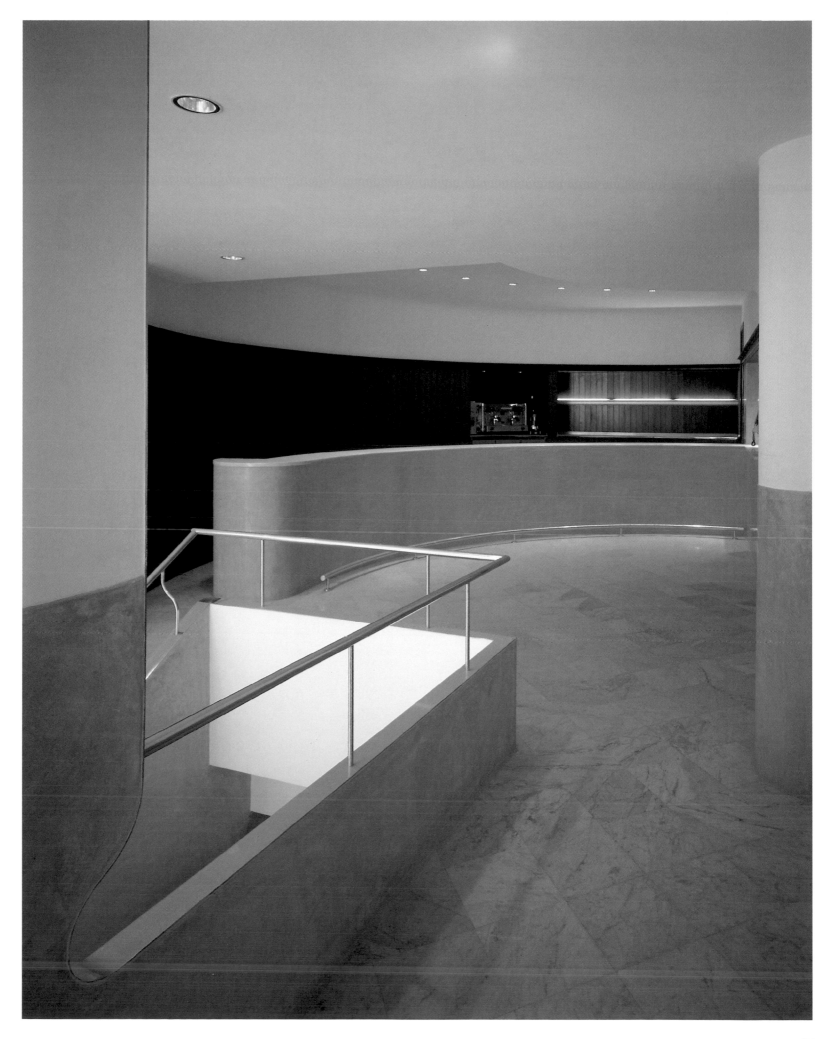

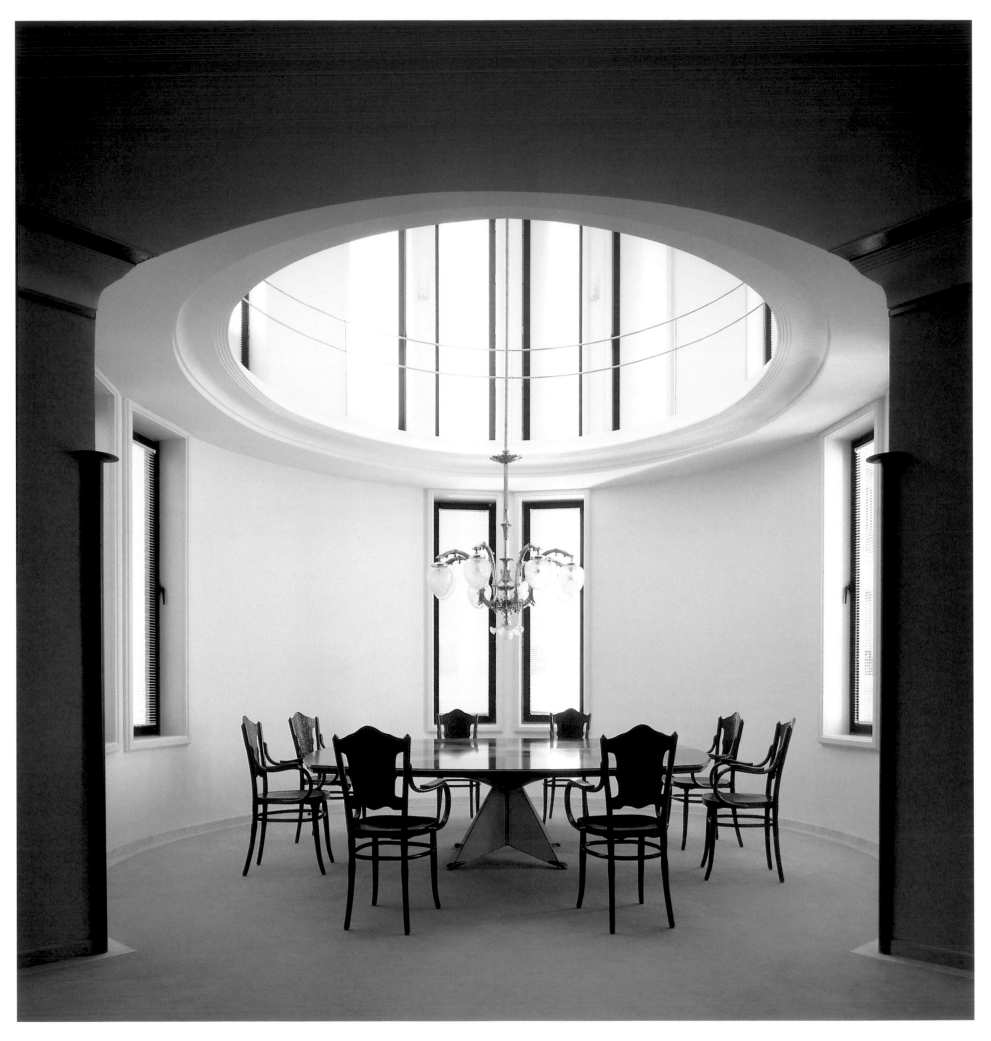

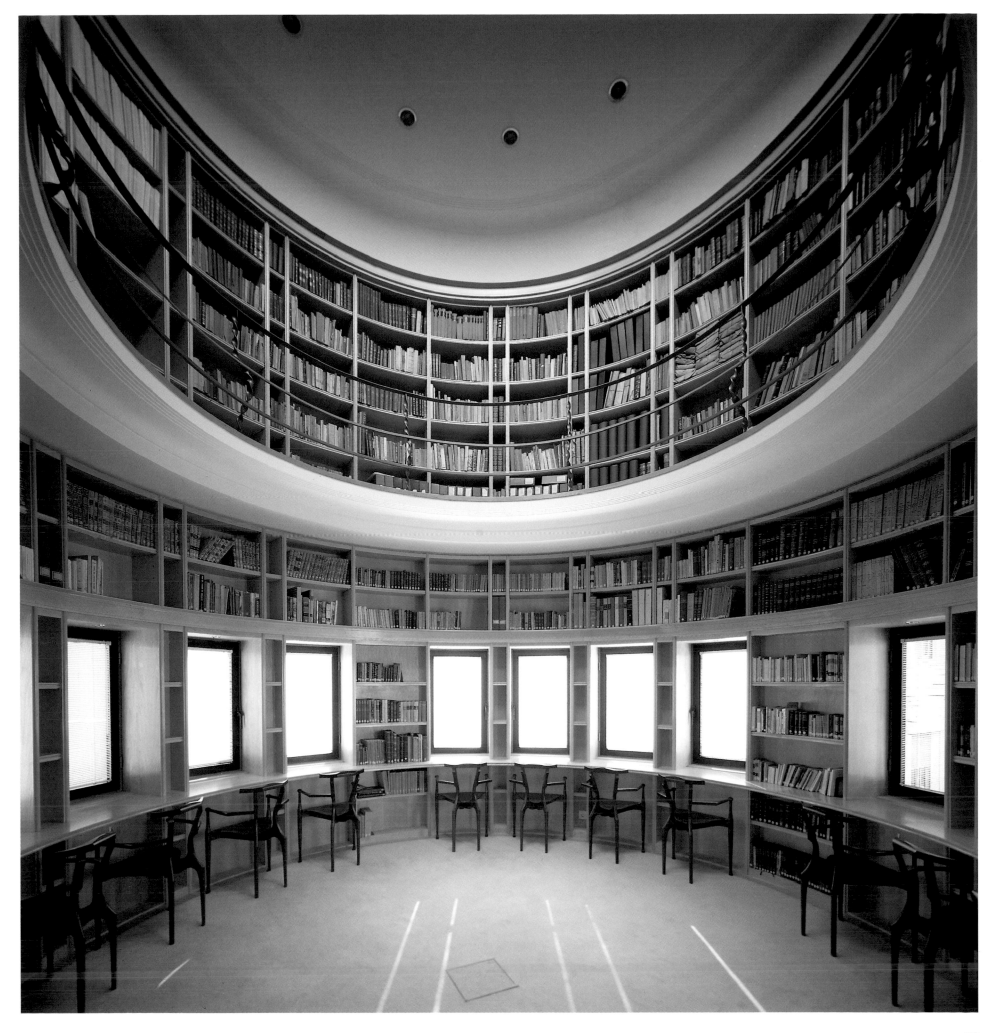

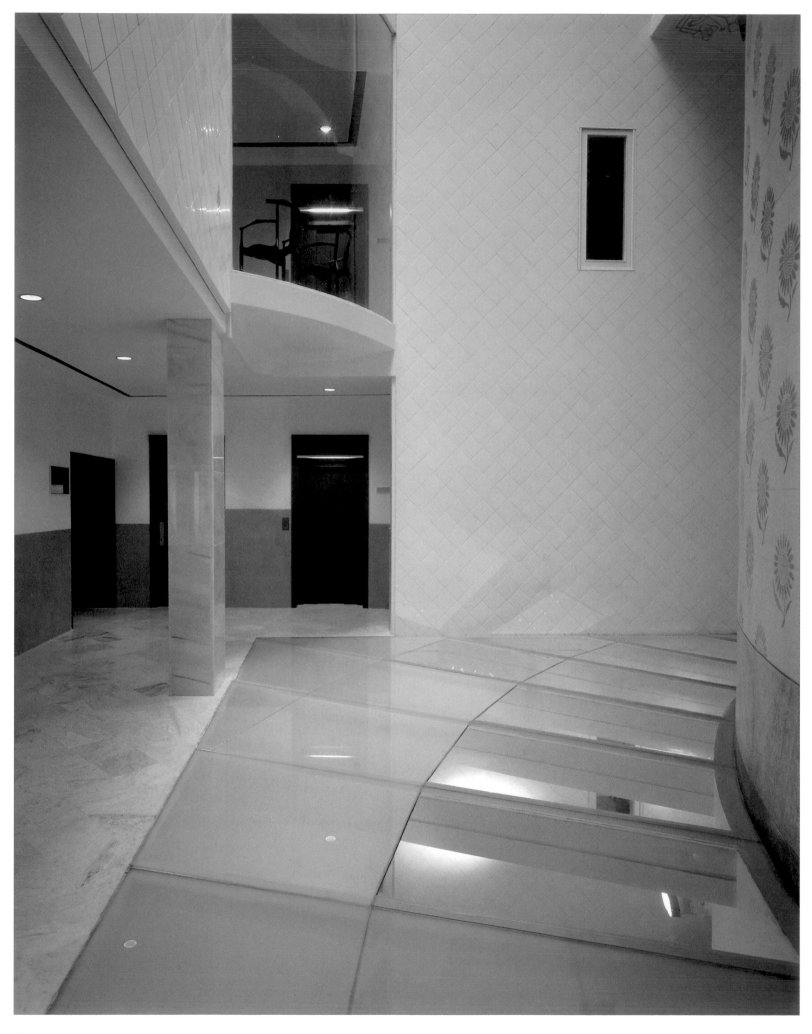

34. Konferenzraum im
neuen Turm an der West-
ecke des Gebäudes.
35. Südwestlicher Teil der
Bibliothek über dem Kon-
ferenzraum.

34. Conference room in
the new tower at the west
corner of the building.
35. South-west part of the
library above the confer-
ence room.

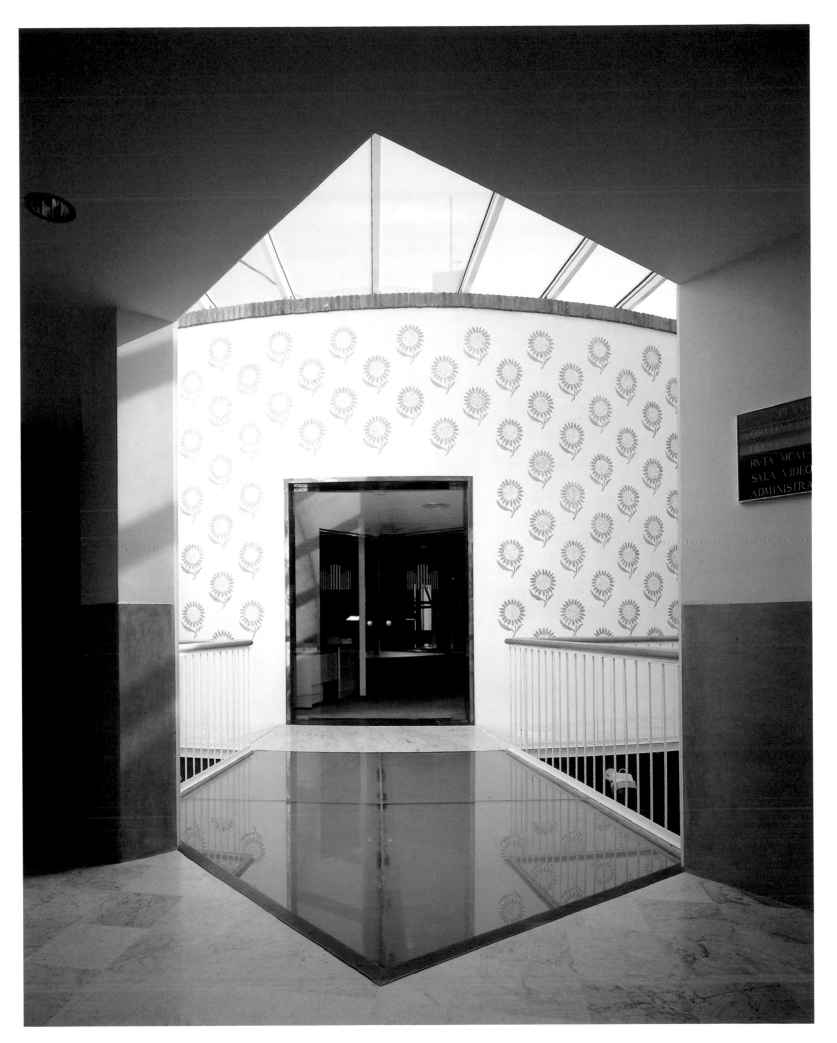

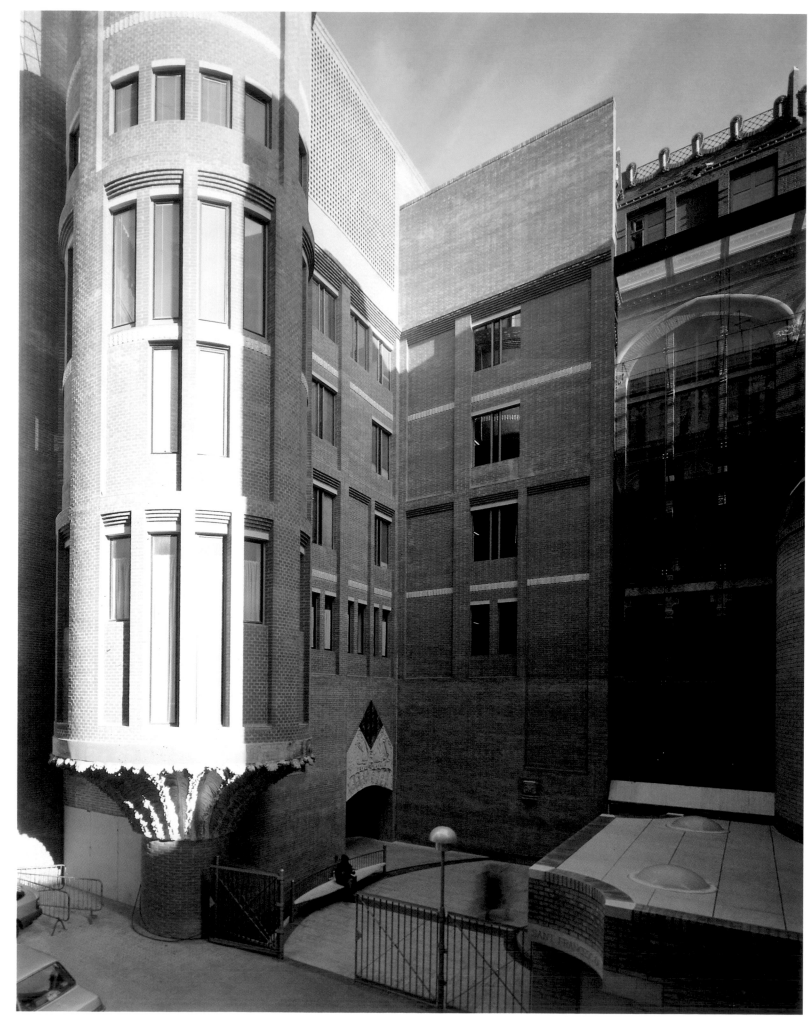

38, 39. Platz vor dem
neuen Eingang.

38, 39. Square in front of
the new entrance.

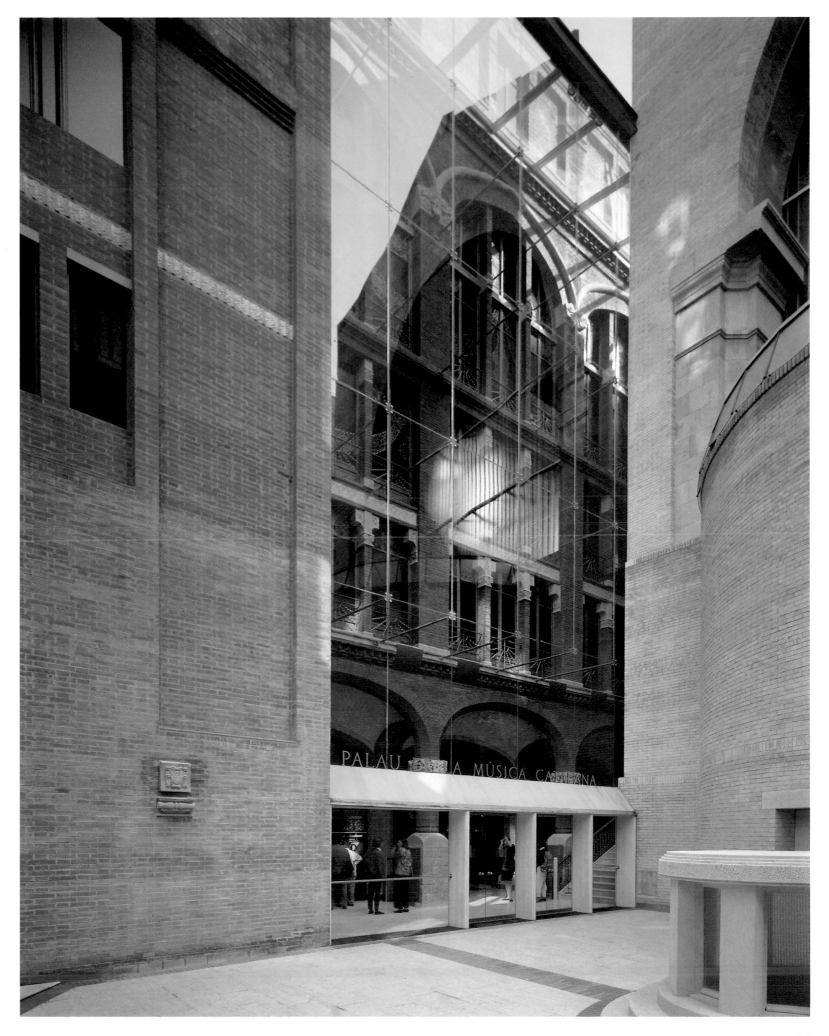

**Erweiterung, Umbau und Restaurierung des
Palau de la Música Catalana, 1983–89**

Architekten: TD&A – Tusquets, Díaz & Assoc.
Vorentwurf: mit Lluís Clotet
Projektleiter: Oscar Tusquets und Carles Díaz
Mitarbeiter: Eduard Permanyer und Pep Palaín
Tragwerksplanung: Enric Torrent
Restaurierung: mit Ignacio Paricio

**Extension, remodeling and restauration of the
Palau de la Música Catalana, 1983–89**

Architects: TD&A – Tusquets, Díaz & Assoc.
Preliminary design: with Lluís Clotet
Project directors: Oscar Tusquets and Carles Díaz
Collaborators: Eduard Permanyer and Pep Palaín
Structural engineering: Enric Torrent
Restauration: with Ignacio Paricio